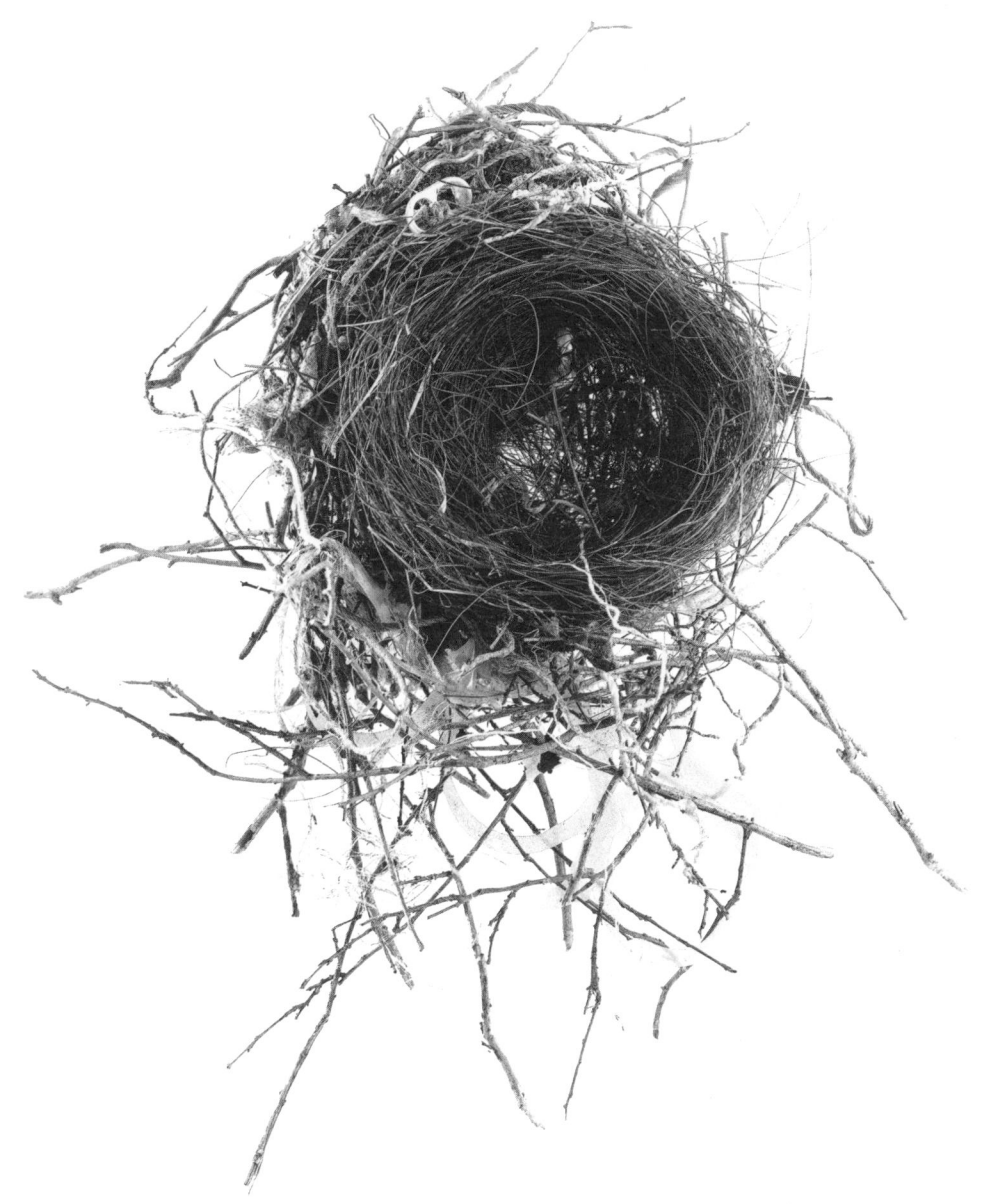

TERRA INCOGNITA

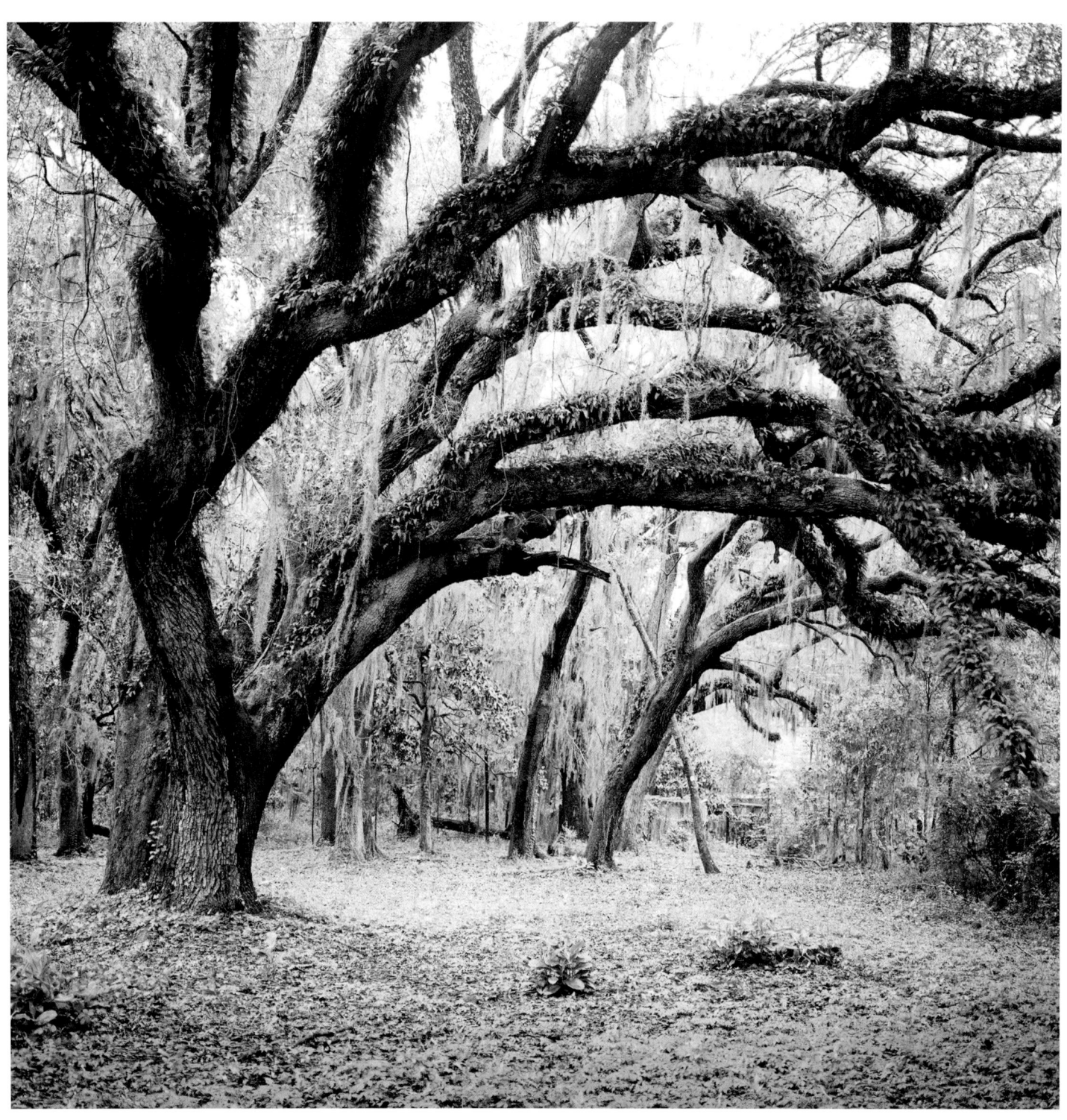

TERRA INCOGNITA

Photographs of America's Third Coast

by Richard Sexton

Foreword by J. Richard Gruber, Ph.D.
Introduction by John Lawrence
Afterword by Randy Harelson

CHRONICLE BOOKS
SAN FRANCISCO

Photography and preface copyright © 2007 by Richard Sexton.
Foreword copyright © 2007 by J. Richard Gruber.
Introduction copyright © 2007 by John Lawrence.
Afterword copyright © 2007 by Randy Harelson.
All rights reserved. No part of this book may be reproduced in any form without written permission from the publisher.

The quotation on page 9 is taken from *The Moviegoer* by Walker Percy, copyright © 1960, 1961, published by Random House, Inc.

Library of Congress Cataloging-in-Publication Data available.

ISBN-10: 0-8118-5854-5
ISBN-13: 978-0-8118-5854-0

Manufactured in China
Designed by Vanessa Dina

Distributed in Canada by Raincoast Books
9050 Shaughnessy Street
Vancouver, British Columbia V6P 6E5

10 9 8 7 6 5 4 3 2 1

Chronicle Books LLC
680 Second Street
San Francisco, California 94107

www.chroniclebooks.com

Frontispiece:
SYNAPTIC PATH [01]
POINT WASHINGTON, FLORIDA 1991

DEDICATION

For the ephemeral things in life, so defined because we are aware they will not last.
The irony, of course, is that nothing is truly permanent. In the end, it is all a matter of degree.
The beauty of photography is that it allows the ephemeral to linger longer.

PREFACE
By Richard Sexton

I began the body of work that has culminated in *Terra Incognita* shortly after I moved from San Francisco to New Orleans in 1991. At the time, my primary photographic interest in the region was the faded grandeur of New Orleans and the River Road. But, rather quietly, I was soon compelled to photograph the landscape. Over the last fifteen years I've traveled and photographed the Gulf Coast from the Mississippi River to the Florida panhandle. It can be a somewhat inhospitable landscape (bring waders and insect repellent, and watch out for snakes), topographically featureless (a change in elevation of two or three feet can be regarded as significant) and fragile (easily obliterated by disruptions of human habitation and whims of nature). In spite of this—or perhaps because of it—I became increasingly fascinated with the low, marshy coastal landscape of the Gulf.

My unexpected intrigue began more or less by accident soon after my arrival in New Orleans. I was working on a book project that would become *New Orleans: Elegance and Decadence*. Randolph Delehanty, my collaborator, had decided his introduction should be illustrated with regional works of art from the various historical periods he would write about. His initial research led him to conclude that the greatest trove of regional art belonged to a single private collector, Roger Ogden. Through a mutual friend, we managed to get ourselves invited to see the collection. The experience was more than I was prepared for: the parlors of the Ogden residence in Uptown New Orleans were filled floor-to-ceiling with paintings, drawings, and watercolors. What caught my eye most in the prolific display were several nineteenth- and early-twentieth-century canvases of swamp scenes. In them, the swamp was portrayed, quite symbolically, as a place of mystery and melancholy. It was an epiphany for me that a significant, though not widely known, school of painting had coalesced around the low-lying, watery landscapes of the region. I left the Ogden residence that night convinced I should attempt to explore and photograph those landscapes.

My primary motivation came from this single event, but it was buttressed by a longstanding compulsion. I've always been drawn to photographic subjects with a past—those things scarred by time and whose perfect beauty has been altered by unseen forces or dereliction. There is a poignancy to this condition I find riveting. It is the state of aftermath—a quiet serenity that fills the void of terminated events. Aftermath is a unique moment wherein the past consumes the present. In the aftermath we are able to absorb the gravity of the predicament in a way that eludes us when we're in the thick of the fray. Many of the images in *Terra Incognita* were made in the wake of storms, hurricanes, and brush fires. Others were taken following more ponderous transforming events, such as saline intrusions from the sea or tidal erosion. I even photographed in the aftermath of college spring break (which isn't typically viewed as having lasting consequences for the natural environment).

I had no preconceptions fifteen years ago about photographing the natural landscape of the Gulf Coast; I simply didn't think it was beautiful or awe-inspiring in a traditional sense. My rather cursory opinion has been shared, unfortunately, by far too many who think that a retreat from the ocean's edge lands one in a morass of machete fodder. Further adding to the mystery and relative obscurity of this region is its very real physical flux. Tropical storms, hurricanes, and other forces of nature perpetually remap the landscape, with noticeable change from year to year.

Alteration beyond recognition is an effective way to make a place mystifying. What nature doesn't change in this region, real estate developers and industry manage to quite efficiently. Lowland hardwood forests rich in plant materials and teeming with wildlife are reducible to an ugly vacant lot in short order, and the reasons for doing so are often arrived at with abandon. In the end, land development is as significant a threat to this landscape as hurricanes or global warming.

I eventually realized that the landscape of the Gulf Coast is in a peculiar way unknown—*terra incognita*—but not because it hasn't been explored, mapped, or inhabited. It's that this landscape has eluded our national psyche. The pursuit of manifest destiny, which began with the Louisiana Purchase in 1803, came to focus national attention on uniting the Atlantic seaboard and the Pacific coast, while the Gulf Coast (the archetypal middle child) languished. In the big scheme of things, it wasn't important. It became, arguably, the accepted and undervalued Third Coast of America.

In many ways, August 29, 2005, changed all that when Hurricane Katrina passed over the Mississippi's delta below New Orleans near West Pointe a la Hache, Louisiana, and then veered east over Lake Borgne, pummeling the Mississippi Gulf Coast and sending a storm surge into New Orleans that inundated the low-lying city. For weeks, the entire country was mesmerized by the baroque spectacle. The debacle of Katrina was a horrific climax to the national focus on the region that had begun a year earlier in Florida, which in 2004 was assaulted by five major hurricanes (though not all of them hit the Gulf Coast). In all these tragedies, the media focused relentlessly on how the built environment and its inhabitants were affected, and to an extent rightly so, because when people and their property are gravely impacted, it is indeed a disaster of human suffering. But, unjustly, part of the tragedy often remains in the shadows when the natural landscape is also a victim of devastation, and is treated as a lesser story—or maybe not a story at all.

Terra Incognita is an homage to the mysterious and misunderstood land that I've come to respect. But my championing of this landscape isn't only directed outward at society, it's directed inward, at myself. We all expect tantalizing discoveries to come from far-flung places, and so it can be quite vexing when they come from our own backyards. The problem is that the familiar is always taken for granted; we are seldom able to look at it objectively and with insight. Sometimes we have to go to those far-flung places just so we can come back and revisit the familiar and see it in a new light. In a painful irony, disasters can be like traveling without going anyplace: they change our perspective of the familiar. In my case, both things happened. At the beginning of this project, I had returned, after a twenty-year hiatus, to the Gulf Coast where I had spent a great deal of time as a child and where I had first laid eyes on the even horizon line of the sea and breathed in the salty ocean air. In recent years, it became familiar again, only nothing stayed the same.

The pines and palmettos were constantly overtaken by subdivisions and strip malls, and the sculptural slopes of the dune line became the foundations of high-rise condominiums. A succession of storms in recent years—Opal, Georges, Ivan, Katrina—made me realize how vulnerable this landscape is. It isn't destined to last in its current state, and, in fact, many of the subjects in my photographs have already seen their context change dramatically.

With only a handful of exceptions, these photographs were taken in winter, which affords a rare opportunity along the Gulf coast; the weather tends to be more overcast and the storms lengthier. When the air temperature and the water temperature of the Gulf are the same, fog develops along the coast that can linger for days. In winter, the dense underbrush dies back, the hardwoods defoliate, and you can actually see into the lowland forests, which during the summer are impenetrable. The landscape is strikingly different during the short winter, and this difference is significant to the character of this body of work, with its focus on cycle, passage, loss, and renewal.

The images in this book, many of which are compositionally square, have been organized in pairs. These image pairs aren't, in most cases, formal diptychs, but I chose them for their resonating relationships. Sometimes a common graphic form united them. In other instances, they worked as vignettes extracted from a larger common landscape. The image pairs are interspersed with panoramas that frame broad, horizontal vistas.

The final component of the photographic essay consists of found objects, photographed in the studio and divorced from their natural context by a plain white background. The found objects were retrieved from the debris left by storms, tidal surges, and, in some cases, summer vacations—a storm of another kind. Photographing these objects in this way renders them as botanicals, whose austere context, singular focus, and scale are emphasized in a way that their natural contexts seldom allow.

Whereas this work is *about* nature, most of it really isn't *of* nature in the purest sense—an untamed landscape far removed from normal human experience or intervention. Most of my subjects could be described as "countryside" or "vest pocket" nature. These images were taken in vacant lots, pastures, an abandoned pecan orchard next to a bank parking lot, a clear-cut tree farm, a parking lot on the edge of the marsh, and urban and state parks. In many cases, these subjects are the remnants of nature on the fringe of development or the edge of town.

I don't camp or hike for days so that I can be amid nature pretending that I'm living in it the same way that bears and owls do. I merely want nature to be something we encounter routinely in our lives: what we look at from the car window when we're on the open road or what we encounter at the edge of town. With ever-increasing frequency, nature isn't in these places. That area of the Gulf Coast that I've photographed was one of the last places in America where there were miles and miles of open coastline, pristine marshes and wetlands, and palmetto scrub for as far as the eye could see. That has all changed, and it's happened in my lifetime. This is my tribute to what's left.

"But things have suddenly changed... This morning for the first time in years, there occurred to me the possibility of a search... I remembered the first time the search occurred to me. I came to myself under a chindolea bush... Six inches from my nose a dung beetle was scratching around under leaves... As I watched, there awoke in me an immense curiosity. I was on to something... This morning when I got up, I dressed as usual and began as usual to put my belongings into my pockets: wallet, notebook (for writing down occasional thoughts), pencil, keys, handkerchief, pocket slide rule (for calculating percentage returns on principal). They looked both unfamiliar and at the same time full of clues. What was unfamiliar about them was that I could see them. They might have belonged to someone else. A man can look at this little pile on his bureau for thirty years and never once see it. It is as invisible as his own hand. Once I saw it, however, the search became possible."
—From *The Moviegoer* by Walker Percy

FOREWORD
By J. Richard Gruber, PhD
Director
The Ogden Museum of Southern Art
University of New Orleans

If there is a specific point of origin for *Terra Incognita,* the expansive series of landscape photographs Richard Sexton produced from 1991 to the present, it appears to have occurred in New Orleans, at the home of art collector Roger Houston Ogden. In 1991, after living and working in San Francisco for more than a decade, Sexton moved to New Orleans, planning to photograph the historic architecture of the city and surrounding region, as Walker Evans and Clarence John Laughlin had done before him. Not long after his arrival, he and Randolph Delehanty, his collaborator on the book *New Orleans: Elegance and Decadence,* were given a tour of the Ogden collection of Southern art. (Ogden would go on to share his collection with the public by founding the Ogden Museum of Southern Art, which opened in 1999.)

Surprised by the scale and impressed by the quality of the collection, Sexton responded most directly to a small number of nineteenth-century landscape paintings, all by artists he was unfamiliar with at the time. Fifteen years later, after numerous subsequent visits to the collection, he still remembers those paintings: Regis Gignoux's *Sunset on Dismal Swamp,* Joseph Rusling Meeker's *Louisiana Dawn,* and George Herbert McCord's *Sunset on the St. John's River.* That tour produced an epiphany; it opened his eyes to a view of his homeland, both literal and transcendent, that took in its unique spirit and beauty. As he has noted, "I left the Ogden residence that night convinced I should attempt to explore and photograph those landscapes."

During a recent interview, Sexton explained that he had "imagined that New Orleans painters would romanticize the landscape, they would go elsewhere for inspiration. I did not expect they would paint *this* landscape." What most impressed him was not the technical skill evident in the paintings but the fact that the artists all used the swamps as the main subjects for their compositions and found resonating symbols and emotion in those swamps. This approach struck a responsive chord, reflecting Sexton's own sentiments about the Southern environments that he finds "moody, foreboding, and threatening."

While this was Sexton's first encounter with the portrayal of the Southern swamp in art, it was by no means his introduction to the swamps and lowlands of the Gulf Coast region. His family is from Colquitt, in the Georgia farming country west of Thomasville, near the Alabama and Florida borders. Sexton grew up there, traveling through the Florida panhandle during the 1950s and 1960s on family vacations to the beaches of Panama City and the region some call the "Redneck Riviera." Georgia's storied Okefenokee Swamp is located about a hundred miles east of Colquitt. He certainly knew swamps, but they had never struck him as a subject for art. Not, that is, until he moved to New Orleans.

After completing an undergraduate degree at Emory University in Atlanta, Sexton moved to California in 1977 with aspirations of obtaining an MFA degree in photography at the San Francisco Art Institute. But both the times and the faculty had changed by the time he arrived at the school. The legendary founding members of the school's photography program had dispersed: "Ansel Adams was retired and living in Carmel. Minor White was teaching at MIT. Edward Weston was dead. I had heard that in the late 1960s the school had a resurgence, with many new, up-and-coming photographers on the faculty. Despite this, the connections to the original faculty were too faint to provide any meaningful continuity." The city had changed as well. "To make things even more anticlimactic, I rented a studio apartment in the Haight-Ashbury, which had reached a nadir by 1977."

While Sexton had great respect for the iconic images that defined the regional masters who had drawn him to California, he found that he was uninspired to create photographs there. Increasingly discouraged by the lack of structure and formal training at the Art Institute in 1977 and 1978, he dropped out of the school and began working as a darkroom technician. By 1980, he was active in commercial photography, with a specialization in architecture. He regards photographing "The Presence of the Past," the seminal American exhibition of postmodern architecture shown in San Francisco in 1982, as a professional turning point. In 1987, he wrote and photographed his first book, *American Style: Classic Product Design from Airstream to Zippo*, beginning his long and continuing relationship with Chronicle Books in San Francisco. Before moving to New Orleans, he completed *The Cottage Book* and a related book on San Francisco architecture, *In the Victorian Style*, with Randolph Delehanty.

By the time he moved to New Orleans, Sexton had established the foundations of his career as a photographer and author, bringing a working structure that is reflected in projects like *Vestiges of Grandeur: The Plantations of Louisiana's River Road*. Sexton had never lived in New Orleans before moving there, although he had visited the city as a college student. Returning to the Gulf Coast from San Francisco, he discovered that the beaches, swamps, and low-lying landscapes he remembered from childhood were increasingly threatened. His experiences and professional training in California, combined with his discovery of the artists in the Ogden collection, suggested that this compelling Gulf Coast environment could serve as a significant new subject for his photography.

The majority of the works in this series were produced in the coastal region extending from Seaside, Florida, to New Orleans Louisiana, locations where he maintains homes. Some were created north of Seaside and during trips back to Georgia. These photographs were created in black-and-white, in contrast to the majority of his commercial photography, and were intended to be seen in galleries and museums, to be acquired by collectors and institutions. However, as he recently noted, they should be considered within the evolution of his commercial work: "My career as an editorial photographer and a commercial architectural photographer honed my abilities, made me viable as an 'artist.'" Sexton's philosophy reflects a professional approach evident in the works of American photographers such as Edward Steichen, Walker Evans, Ansel Adams, Diane Arbus, Irving Penn, Joel Meyerowitz, Robert Mapplethorpe, Eugene Smith, Richard Avedon, and Herman Leonard, all of whom balanced success as commercial and "art" photographers.

Terra Incognita developed along with a related series executed over a similar period of time. Entitled *The Highway of Temptation & Redemption: A Gothic Travelogue in Two Dimensions*, it was devoted to Southern roadside imagery, including vernacular signs and structures in the natural environment. This series served as the focus of a unique artist's book, written and designed by Sexton, and was the subject of his first museum exhibition, presented at the Ogden Museum of Southern Art (April 11–July 17, 2005). Together, these series reflect his vision of the changing natural environment of the coast, and the related erosion of the man-made roadside environments along the Gulf Coast South, during his lifetime. For Sexton, these are subjects equal in stature to those of the California landscape photography school, and are more important to him and his sense of place.

The photographs in *Terra Incognita* also reflect Sexton's concerns about the endangered Gulf Coast, an environment not just in a state of natural change but threatened by development and expanding populations. The majority of these images were created before Hurricane Katrina and Hurricane Rita struck the Gulf Coast, and while a series of earlier hurricanes swept across Florida. All reflect his perception of an important distinction: "I photograph scars, not wounds." He has not responded to the published photographs of the Katrina and Rita landscapes because, for him, most focus upon the "wounds," which are "open," showing the immediate and obvious injuries to the region. In his post-Katrina photographs, as in all of *Terra Incognita*, he captures the "scars," the "symbols of survival," the closed and healing wounds. He relates these to his better-known photographs, devoted to the historic and mutated architectural forms he discovers in and around New Orleans, survivors of both man-made and natural disasters.

In the post-Katrina environment of New Orleans and the Gulf Coast, and in recognition of Richard Sexton's long-standing relationship to the Ogden collection, it seems most appropriate that the Ogden Museum of Southern Art participate in the exhibition of this project, *Terra Incognita*, as well as in the related publication of this book. Our presentation of *The Highway of Temptation & Redemption: A Gothic Travelogue in Two Dimensions* underscores our recognition of the importance of his larger photographic vision. Following a path and a vision of the coastal South established by painters such as Regis Gignoux, Joseph Rusling Meeker, George Herbert McCord, and Martin Johnson Heade, and extended by photographers including William Henry Jackson, Walker Evans, and Clarence John Laughlin, Richard Sexton's *Terra Incognita* is a significant addition to the visual history of the Gulf Coast South.

INTRODUCTION
The Road Taken
By John Lawrence

When Richard Sexton photographs the natural landscape, he participates in one of the medium's oldest and grandest traditions. This is not to say that he emphasizes a canonical majestic landscape—immense mountains, raging cataracts, and undisturbed forests. Such subject matter, while it may be increasingly harder to find, still exists; but Sexton's quarry in the landscape is the hidden, the subtle, and the elliptical. The picturesque, though sometimes conceded in his photographs, is not his primary objective. Elements of classical, even conventionally beautiful, imagery do pass before his lens, but in an unobtrusive and quiet way: a small and simple marine form monumentalized by its isolation in *Atrophied Seashell* [plate 32], a hazy line of trees defining the distant horizon of *Tree Study No. 2* [plate 35], or a thicket dense with possibilities of what lies beyond in *Peering from One Reality to Another* [plate 08].

Throughout history, photographers have often chosen the subjects that they know, if not best, then at least well. This familiarity breeds the intimacy revealed in such series as Emmet Gowin's photographs of his family; the quiet corners of Paris frequented by Eugene Atget; Ray Mortenson's New Jersey meadowlands; and Debbie Fleming Caffery's smoky cane fields in Louisiana's sugar country. Sexton acknowledges the influence of Clarence John Laughlin in his work, in a poetic approach that at times may be as formidable as an elegy or an epic, or as spare as a haiku. Like Laughlin, Sexton is well-known as a photographer of the built environment, and, also like Laughlin, he acknowledges the impact that the passage of time has on the subjects he photographs. While the decay of buildings and other structures may more easily show a transition from one era to another, changes that occur in nature are often subtle. Though the transformation in subject is the residue of an event, Sexton wants the catalyzing incident itself to register in these photographs. He wishes to "trigger a visualization in the viewer's head, a synthetic memory if you will, of the event itself, which can be quite powerful." This collection of Sexton's photographs provides new evidence that relentless pursuit of a single subject over a period of time (in this case from 1991 to 2006) can, in the hands of an artist, produce a body of work in which meaning both distills and proliferates.

A lifelong and frequent traveler by automobile along the Gulf Coast from his native Georgia to his adopted home of New Orleans, Richard Sexton has taken notice of this at first unassuming but always changing landscape, which has been called everything from the Third Coast to the Redneck Riviera. The region seems to enter a national public consciousness only when a storm named Camille, Bob, Ivan, or Katrina calls attention to it as a target. As a landscape it has been continually drawn and redrawn by nature's forces—and also experiences dramatic ongoing change through human presence. Sexton feels this presence more than he describes it explicitly, but in pictures like *Fragile Relations* [plate 83] he takes a more direct approach. A landscape that Sexton acknowledges as "underappreciated," the world illuminated here is one that nonetheless serves his interests as a documenter and as an explorer of subtle character.

It is a staple of any book of children's riddles. Question: What goes from coast to coast but never moves? Answer: The road. Earlier versions of this road—the railroads—did not allow a close appreciation of the land they traversed, despite the romantic promise put forth in trains named the Gulf Wind, the Mobilian, and the Azalea. The more versatile mobility of the automobile, and the infinitely more malleable routes that it therefore permitted, was necessary for close study. The road is both Richard Sexton's itinerary and his guide. But the paradox of Sexton's road is that by being a fixed path, it is also an invitation to stray. Its more or less linear character encourages determination and accomplishment, but at the same time offers the inquisitive mind many opportunities to explore. The locales near Colquitt, Georgia; Walton County, Florida; and the countryside near New Orleans are the most productive of these destinations. Using these three loci, the photographs herein take us along on Sexton's side trips, meanders, loops, and dead ends of those areas. Most were made within a short walk of the primary road, often in locations that rubbed shoulders with commercial development.

A few were reached only after expending considerably more effort. He approaches his subject with the familiarity of an intimate, a partner in a relationship that produces new discoveries where others see none. What we discover in Sexton's company is a world of surprises, digressions rich with voluble narrative prospects. In making these photographs, he advocates no cultural imperative other than presenting what may be unfamiliar within the familiar.

A formal aspect of these photographs serves as a counterbalance to a sort of chaos within. Square and panoramic presentations are stable and, in the case of the square pairs on facing pages, both the reality and prospect of a diptych results. The leisurely width of the panoramas permits the eye to make its own wandering journey across the image, in some small way mimicking the road trip made by the photographer.

Richard Sexton's notion of landscape is one that accommodates and embraces a certain amount of change, though the baseline from which that deviation is measured may vary greatly. One set of images—frame-filling closeups of ordinary objects—offers a different take on the land. These images, in their near-clinical recording of objects presented as so many laboratory specimens, recall a sweep of photographic history that stretches from the botanical subjects of Anna Atkins made in the 1840s and 1850s to Walker Evans's celebration of hand tools at the mid-twentieth century to more recent works by Irving Penn: cigarette butts visually salvaged from urban thoroughfares and printed some fifty times their actual size. The pictures use scale as a way of tracing evolution: the smaller the scale, the more change is evident, as seen in a barnacle-encrusted chunk of Styrofoam [plate 30], a lichen-covered pinecone [plate 48], or a bar of soap, pocked and eroded by rain so it resembles a Stone Age ax head [plate 44].

In other images, such as *Symmetry Study: Sea and Clouds* [plate 16] or *The Three States of Matter: Solid, Liquid, Gas* [plate 29], the idea presented is of "the landscape immortal." Patterns of sea and sky come and go, but the sea and sky as entities remain constant. The individual elements of these pictures, subsumed as they are by the larger area of the frame, do not act as the witnesses to evolution. Rather, they present the comfortable notion that such things will always exist. It feels as if Sexton monitors such landscapes with a clock that keeps geological time.

Still other images depict time measured with a stopwatch—the violent snapping of a tree in *Deference* [plate 10] or the disarrayed trunks piled like jackstraws in *Fallen Willows* [plate 53]. To greater or lesser degrees, these images show a landscape nudged off its foundations, a new baseline and order waiting to be redrawn. Throughout it all, Sexton remains an observer, a timekeeper rather than a participant in the process of change. Whether it is dunes recording the cadence of wind and waves or a treeline in one photograph that is echoed in a line of mechanical cranes in the next, pattern, connection, and recapitulation connect these images just as surely as the road connects the places where they were made.

Writing in the 1990s, critic Andy Grundberg suggested that during the previous decade, one task of photographic artists had been to preserve the natural beauty of the world, a beauty that was in danger of being overwhelmed by human advances. Richard Sexton not only finds beauty in the landscape, but meaning and worth. In the end, these photographs, through the explorations of their maker, foster some understanding of the lesser known, permitting us to find, in this unknown land, recognition and universal truth.

PLATES

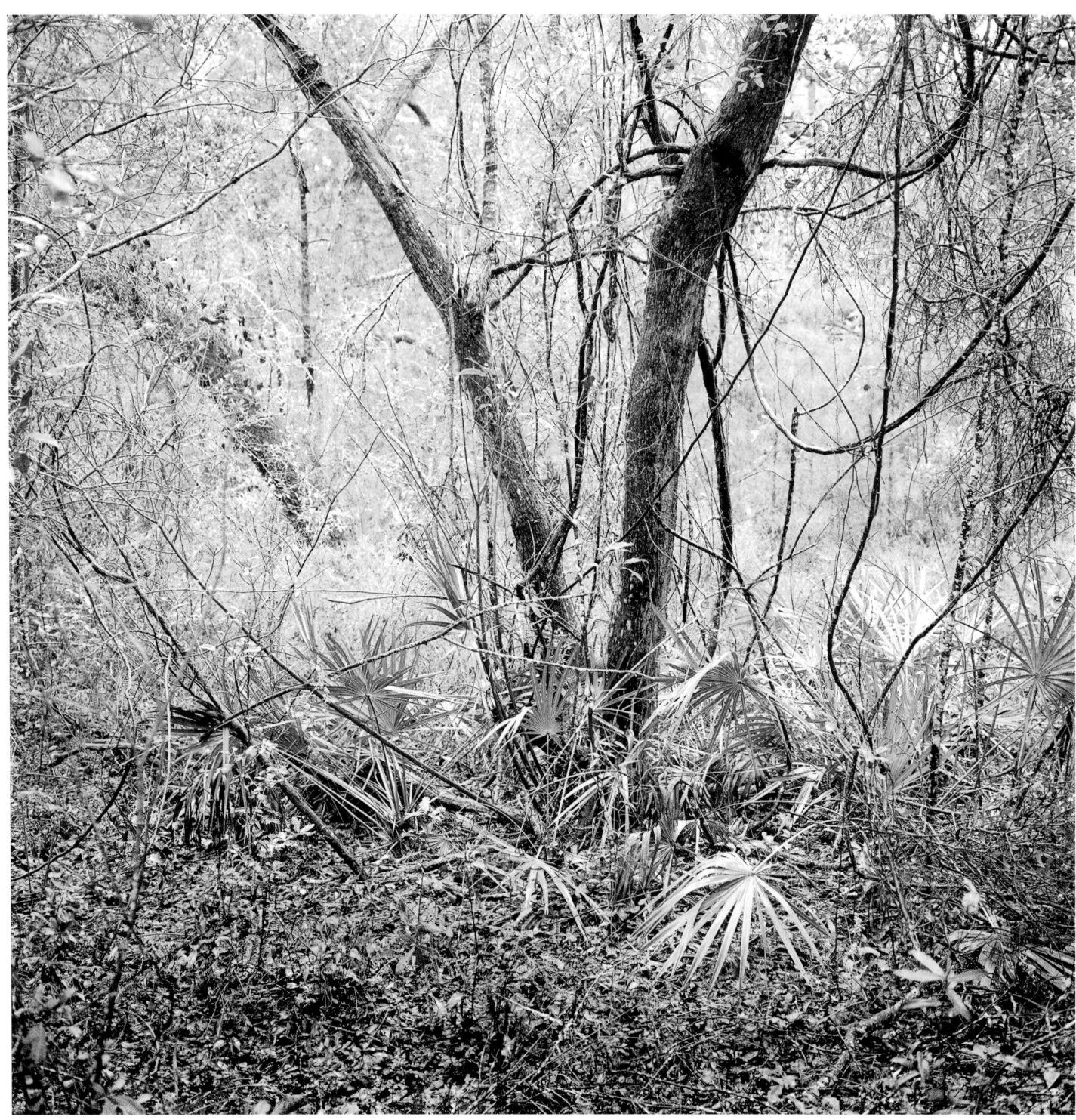

THE SEARCH FOR ORDER FINDS CHAOS [02]
SEAGROVE BEACH, FLORIDA 1992

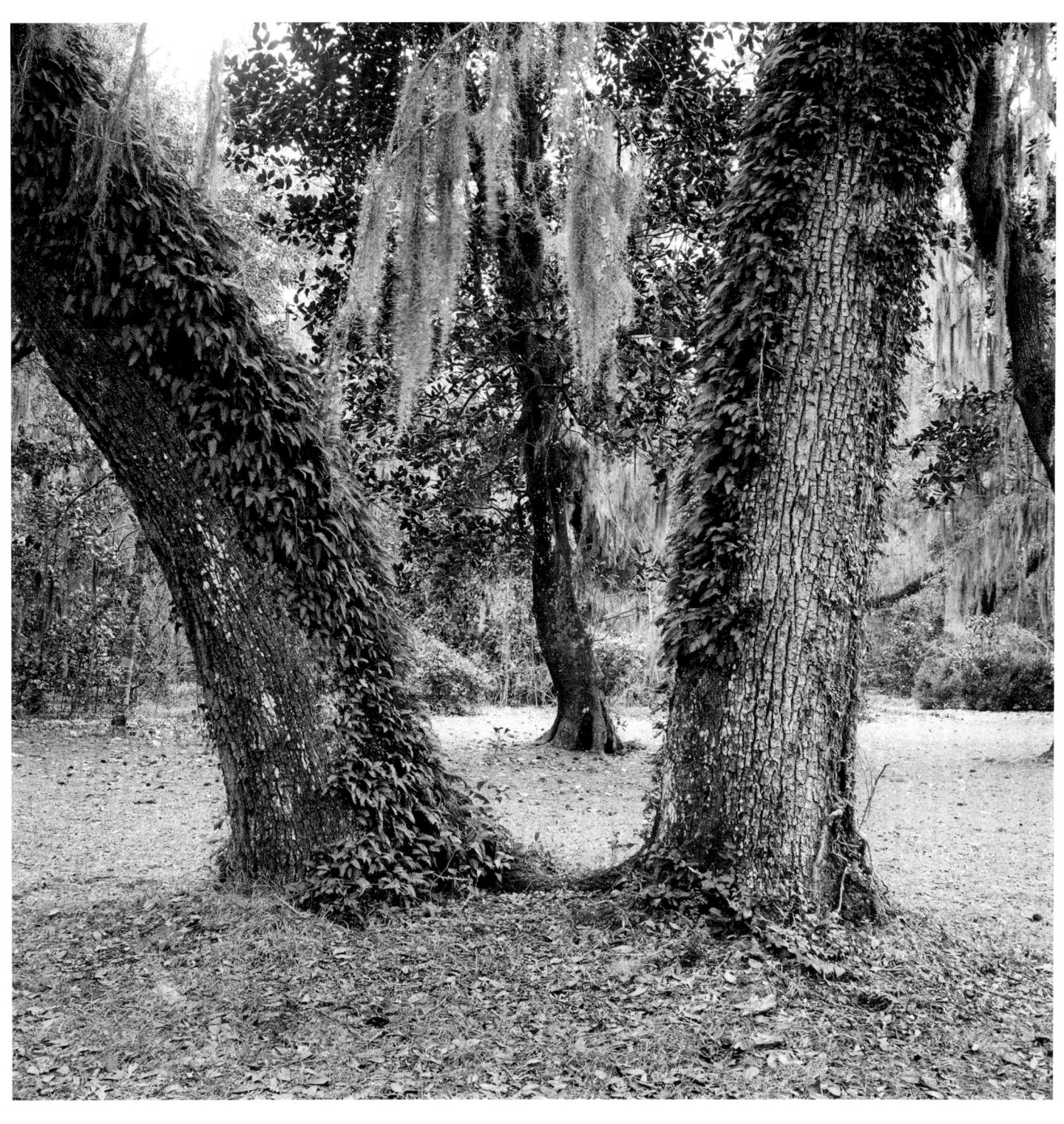

THE EFFECT OF TIME ON SYMMETRY [03]
EDEN STATE PARK, POINT WASHINGTON, FLORIDA 1992

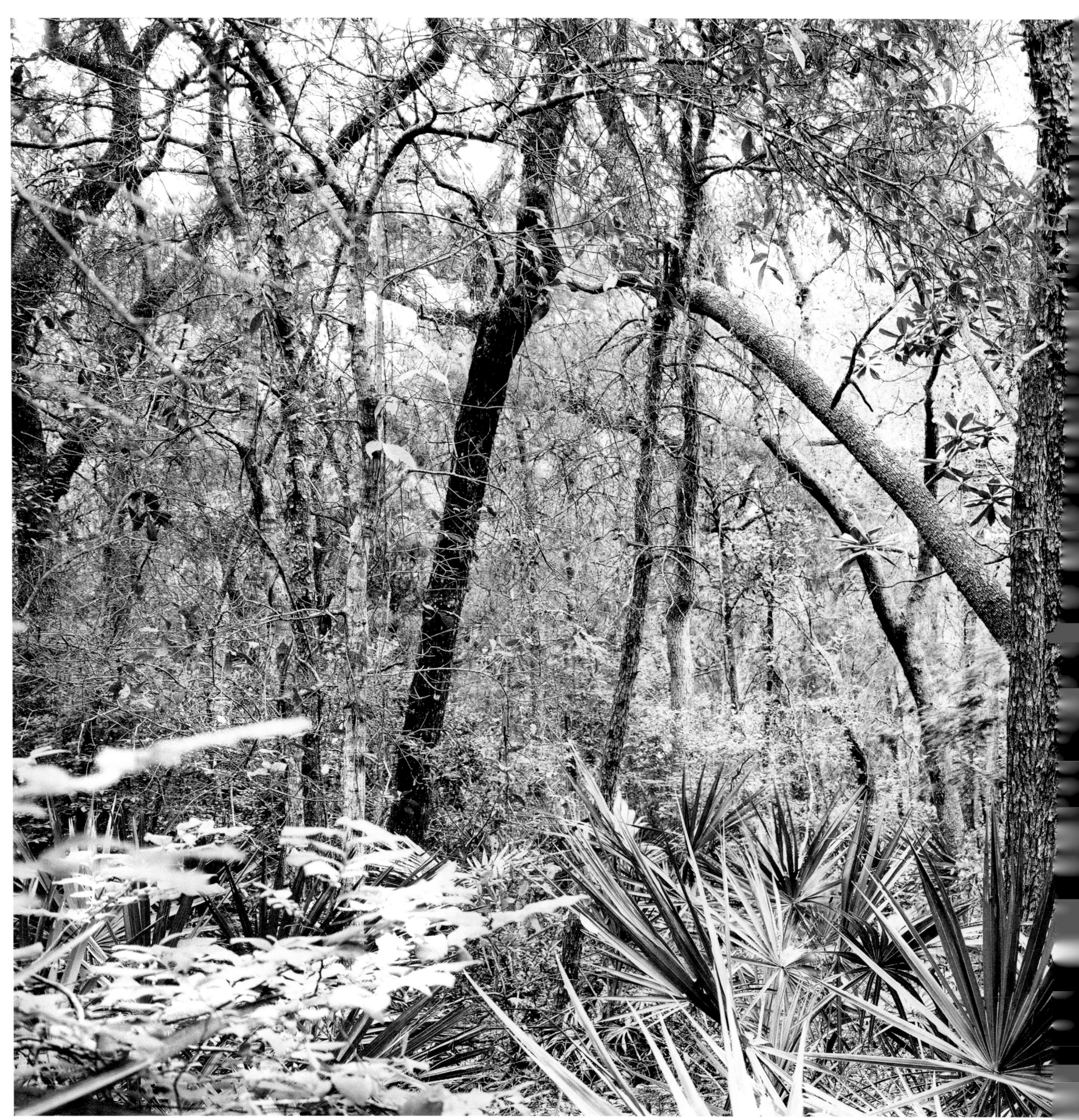

PALMETTOS ASCENDING [04]
SEAGROVE BEACH, FLORIDA 1992

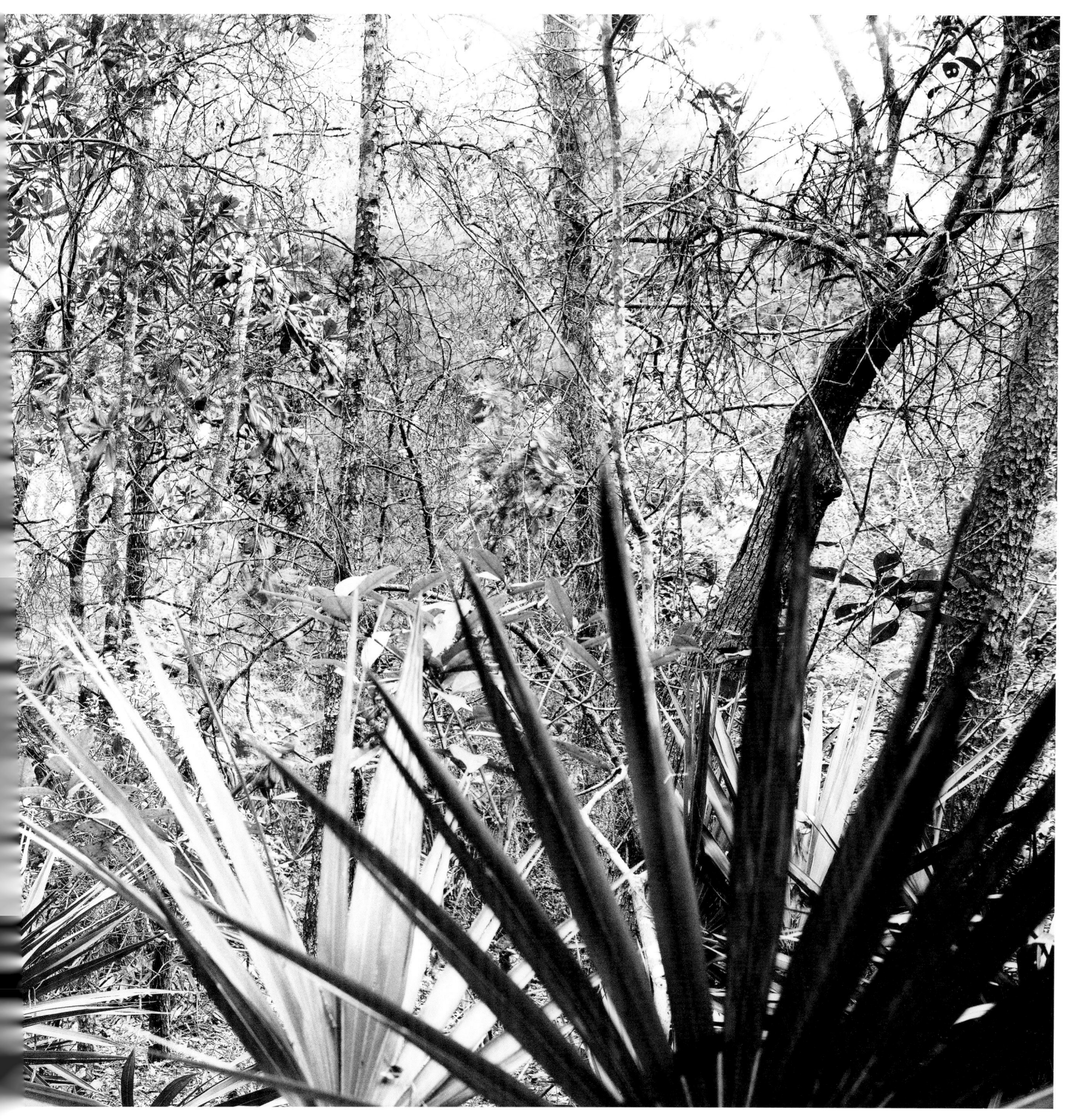

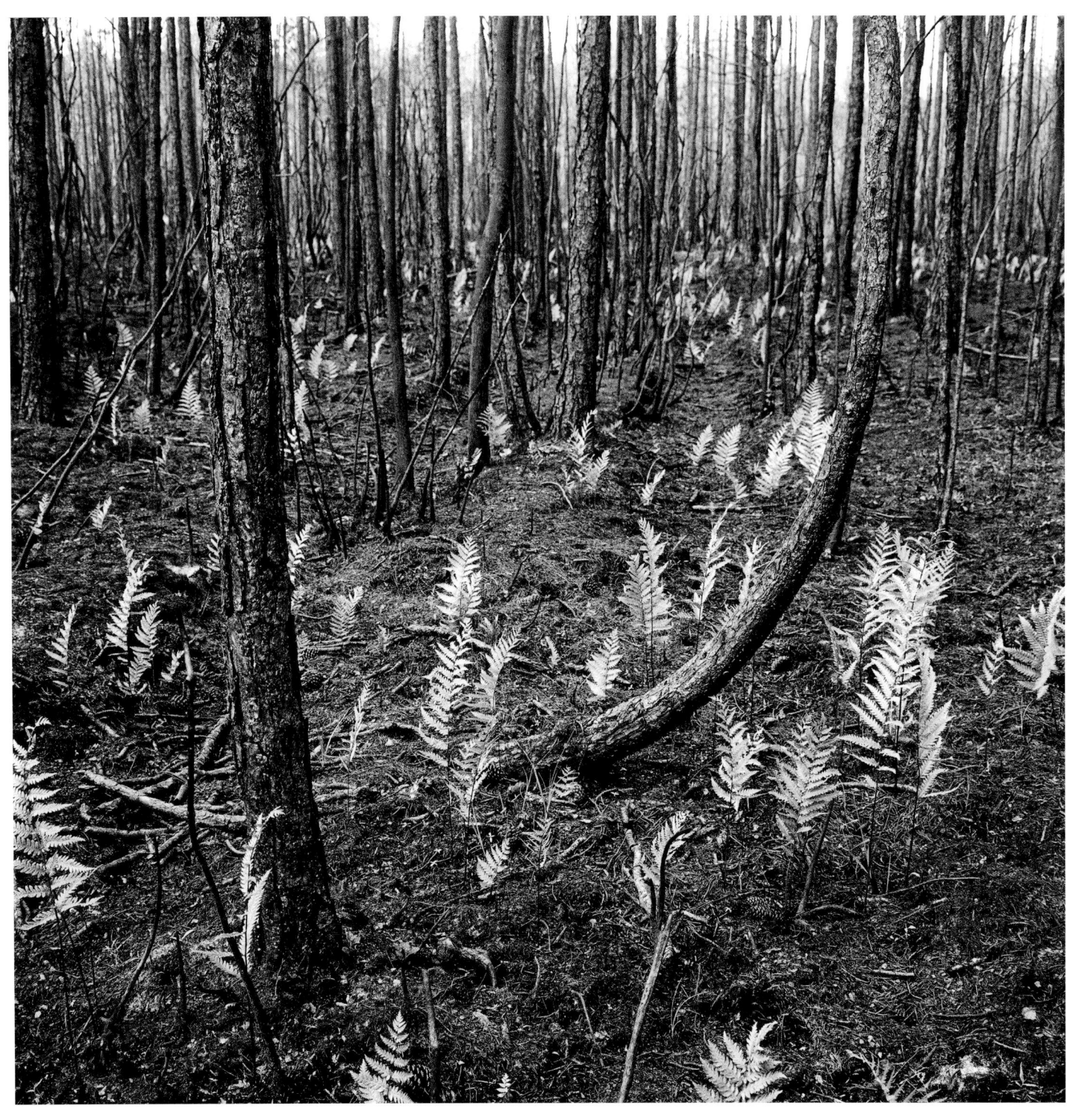

PHOENIX FERNS [05]
ALONG HIGHWAY 98, WALTON COUNTY, FLORIDA 1992

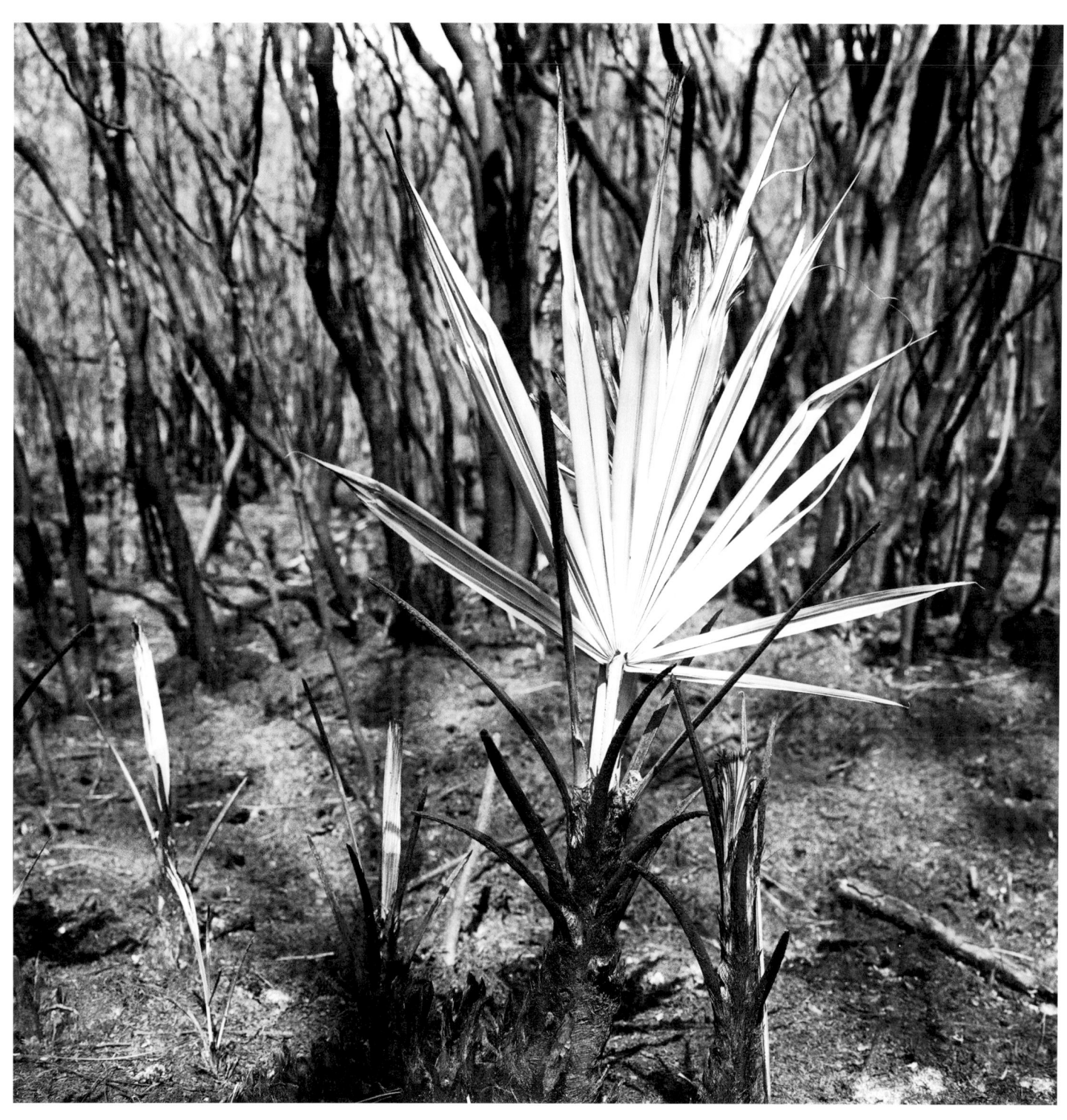

PHOENIX PALMETTO [06]
ALONG HIGHWAY 98, WALTON COUNTY, FLORIDA 1992

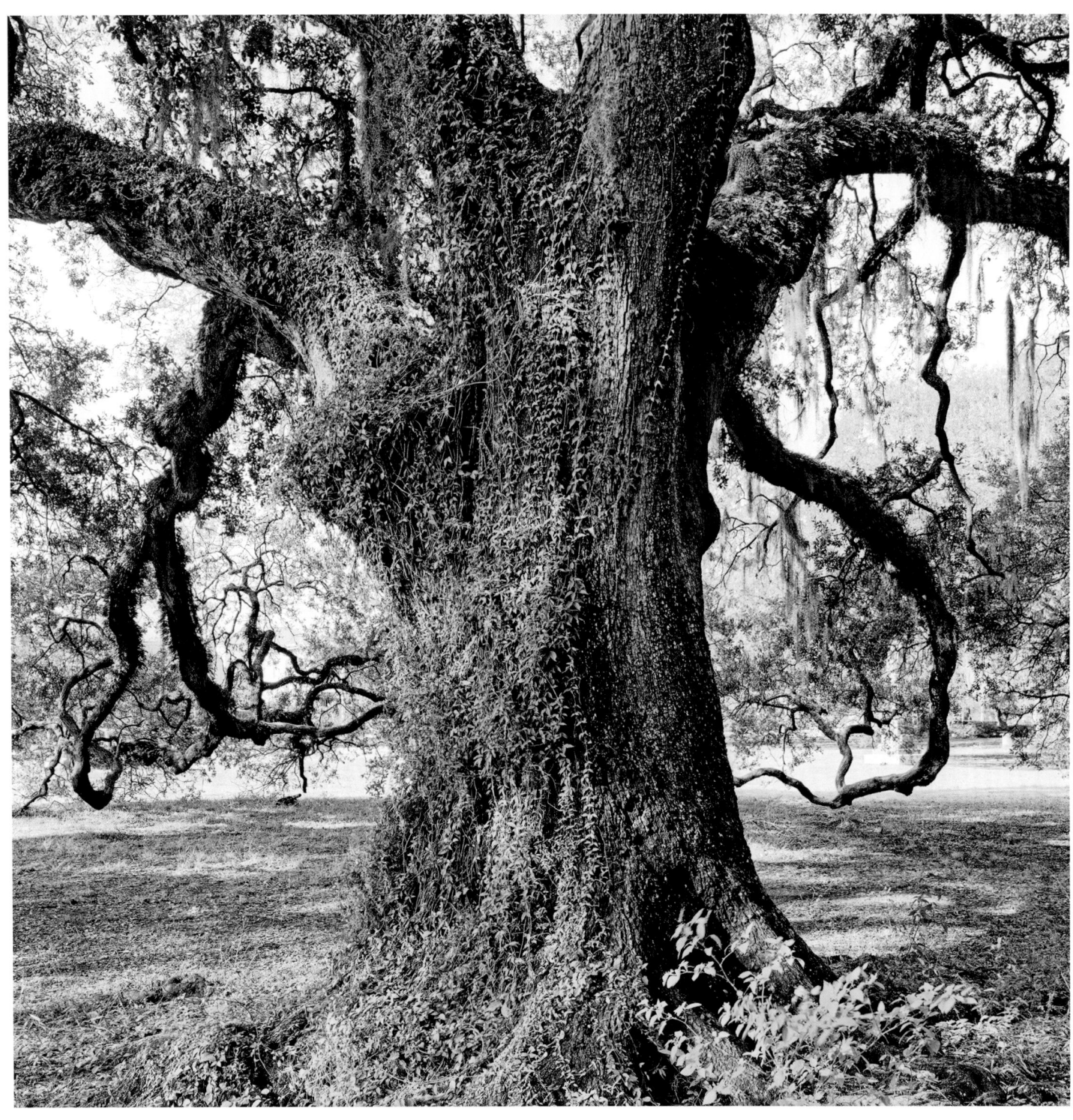

TRUNCATED OAK [07]
CITY PARK, NEW ORLEANS, LOUISIANA 2000

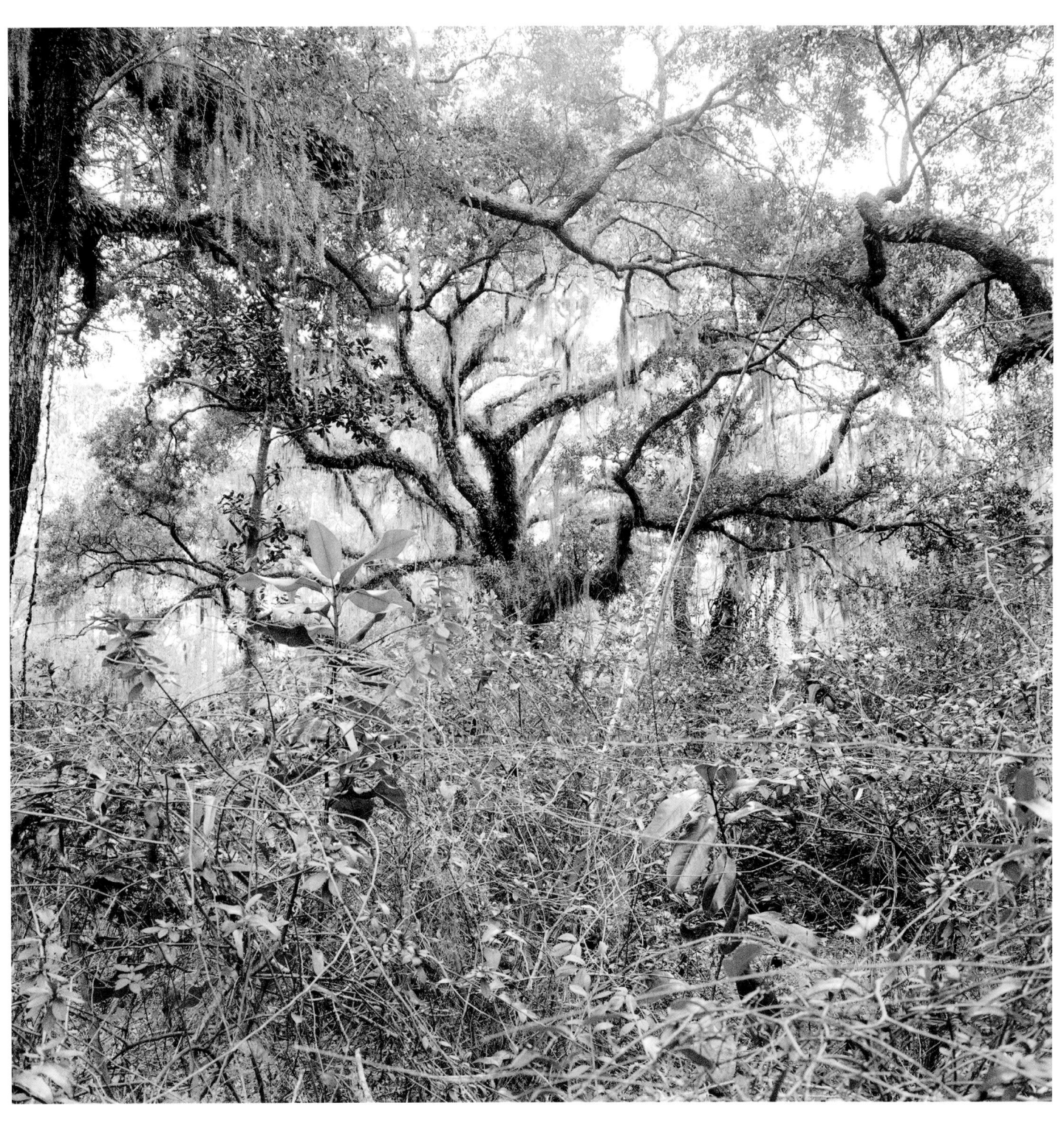

PEERING FROM ONE REALITY TO ANOTHER [08]
EDEN STATE PARK, POINT WASHINGTON, FLORIDA 1992

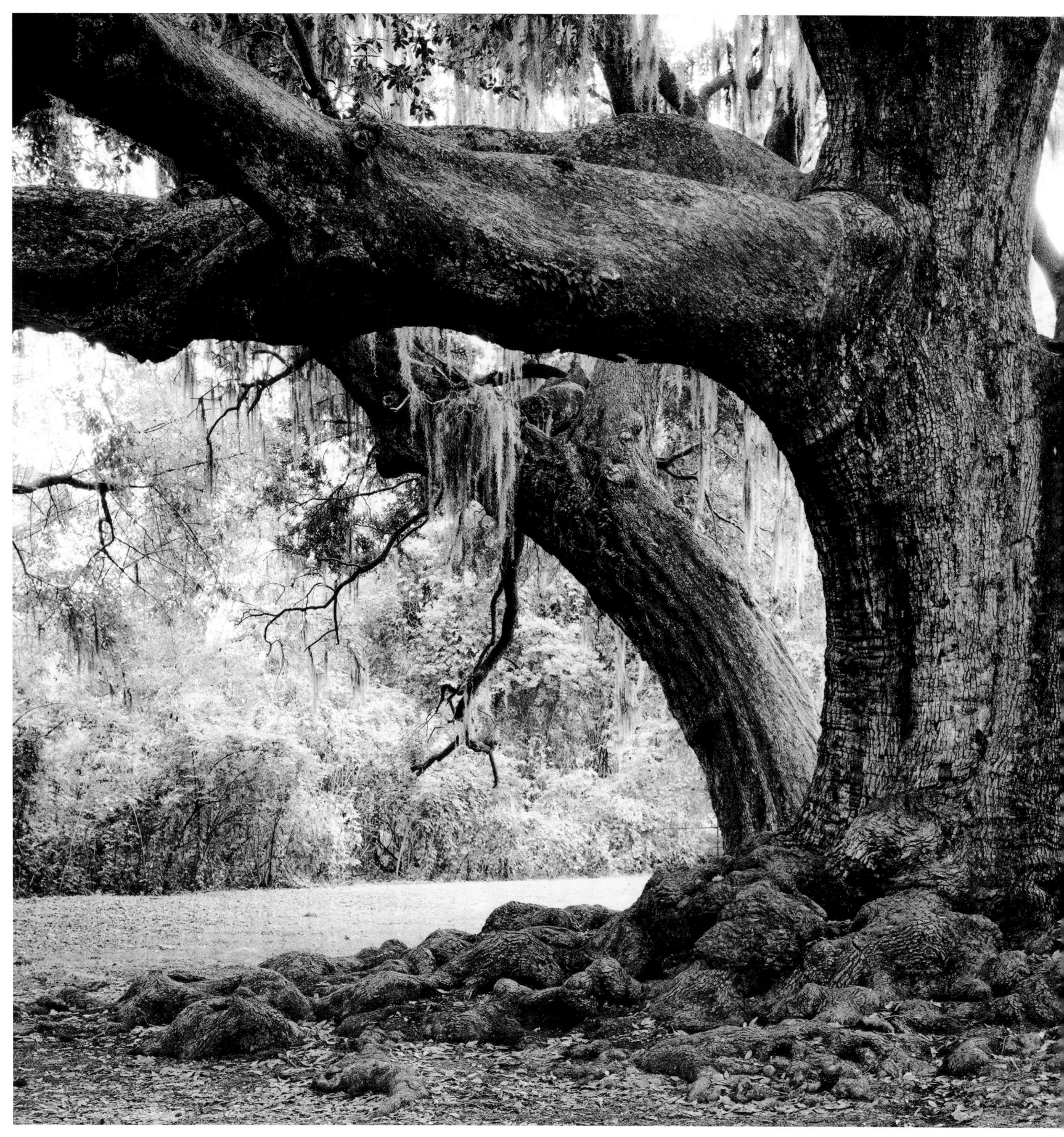

ETIENNE DE BORÉ OAK [09]
NEW ORLEANS, LOUISIANA 2000

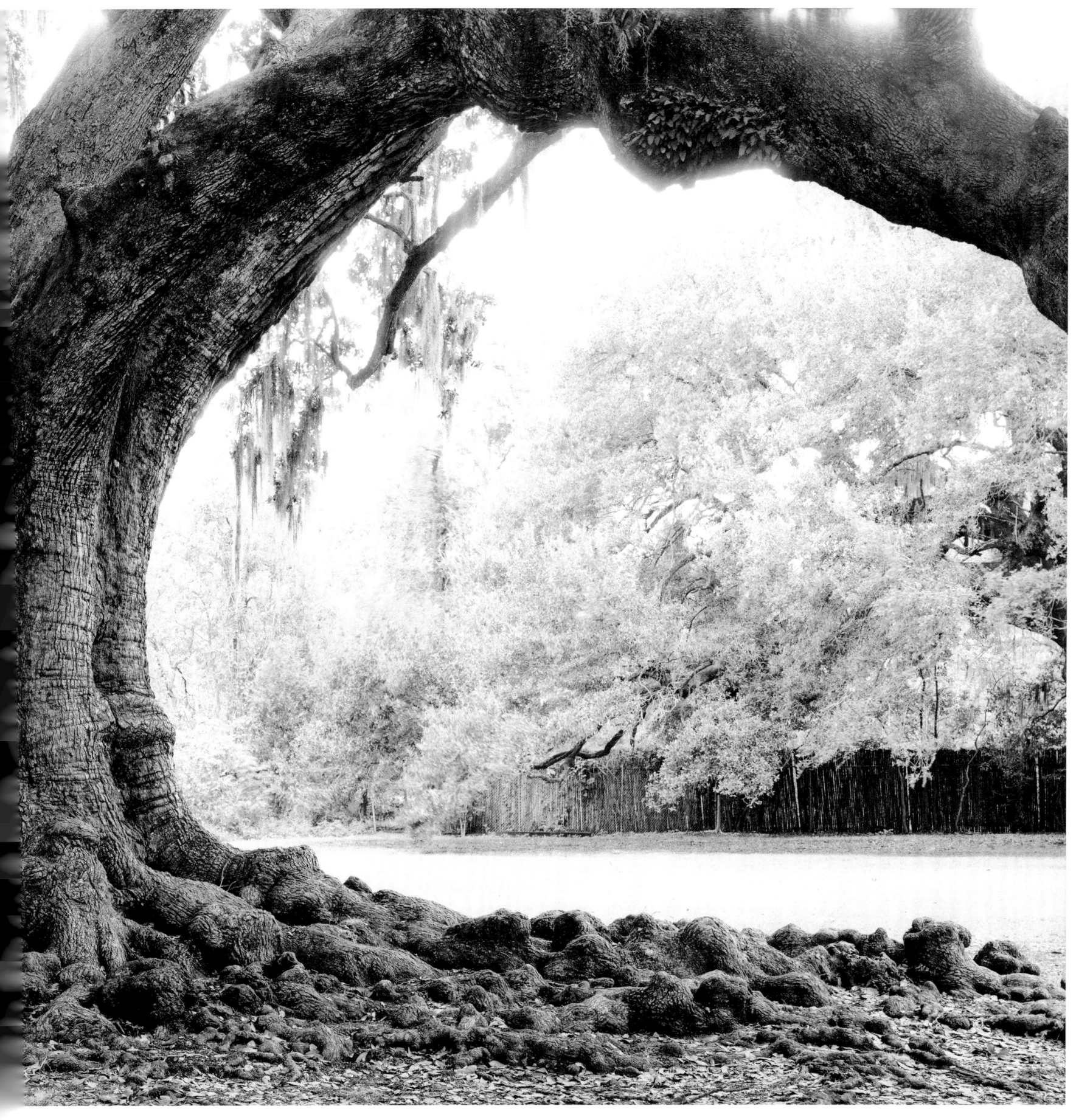

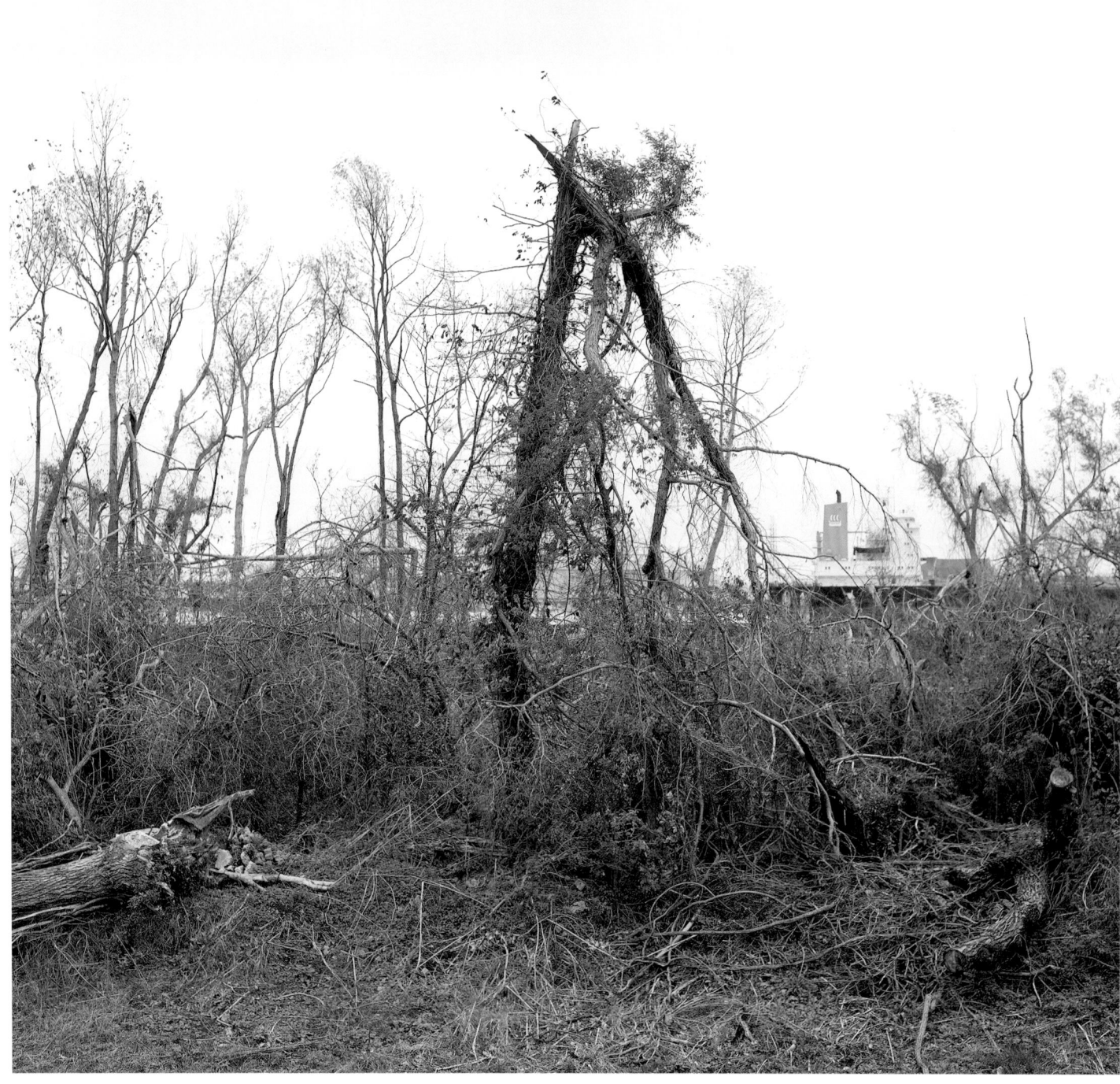

DEFERENCE [10]
ALGIERS POINT, LOUISIANA 2006

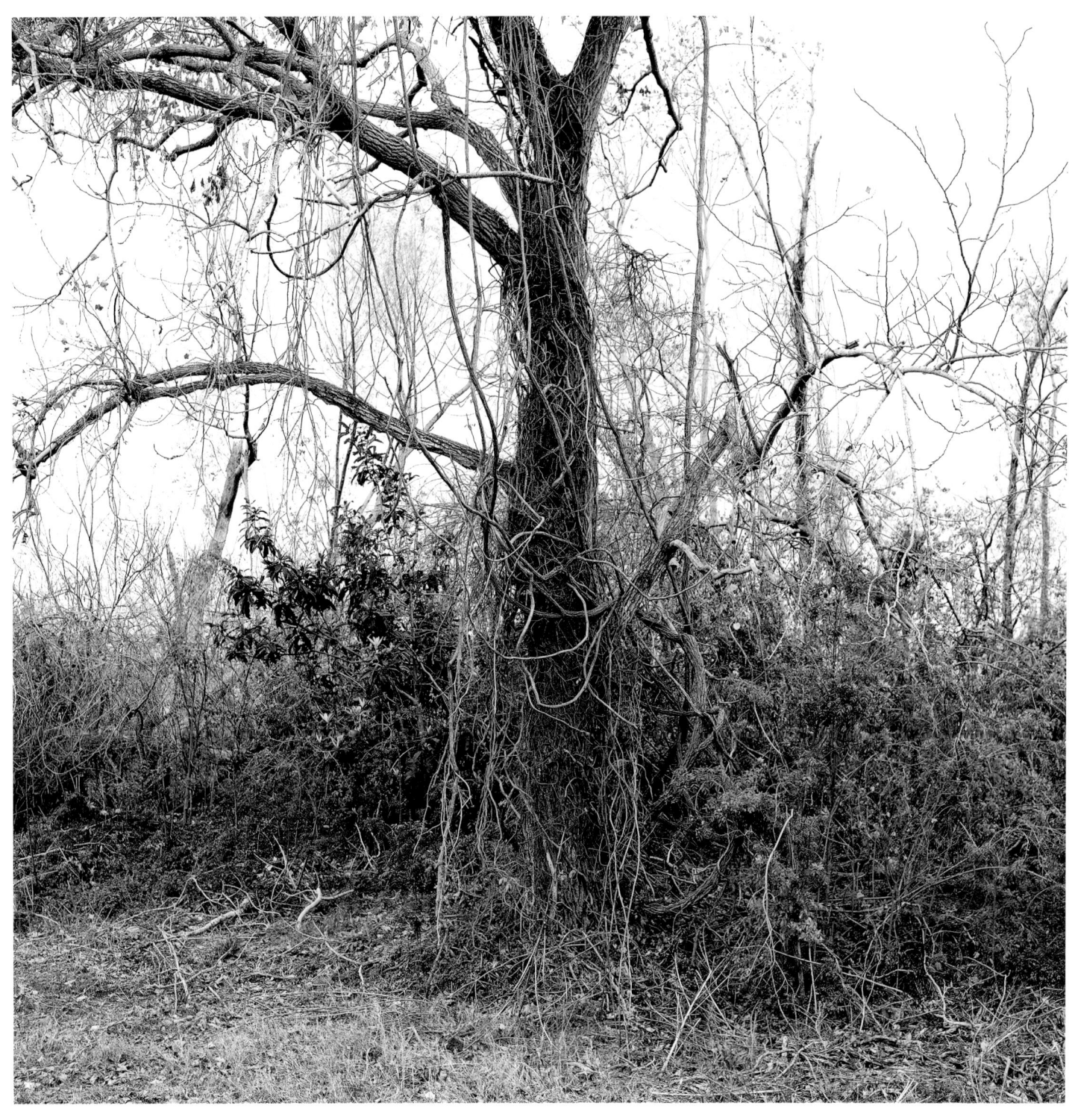

WRITHEN TREE [11]
ALGIERS POINT, LOUISIANA 2006

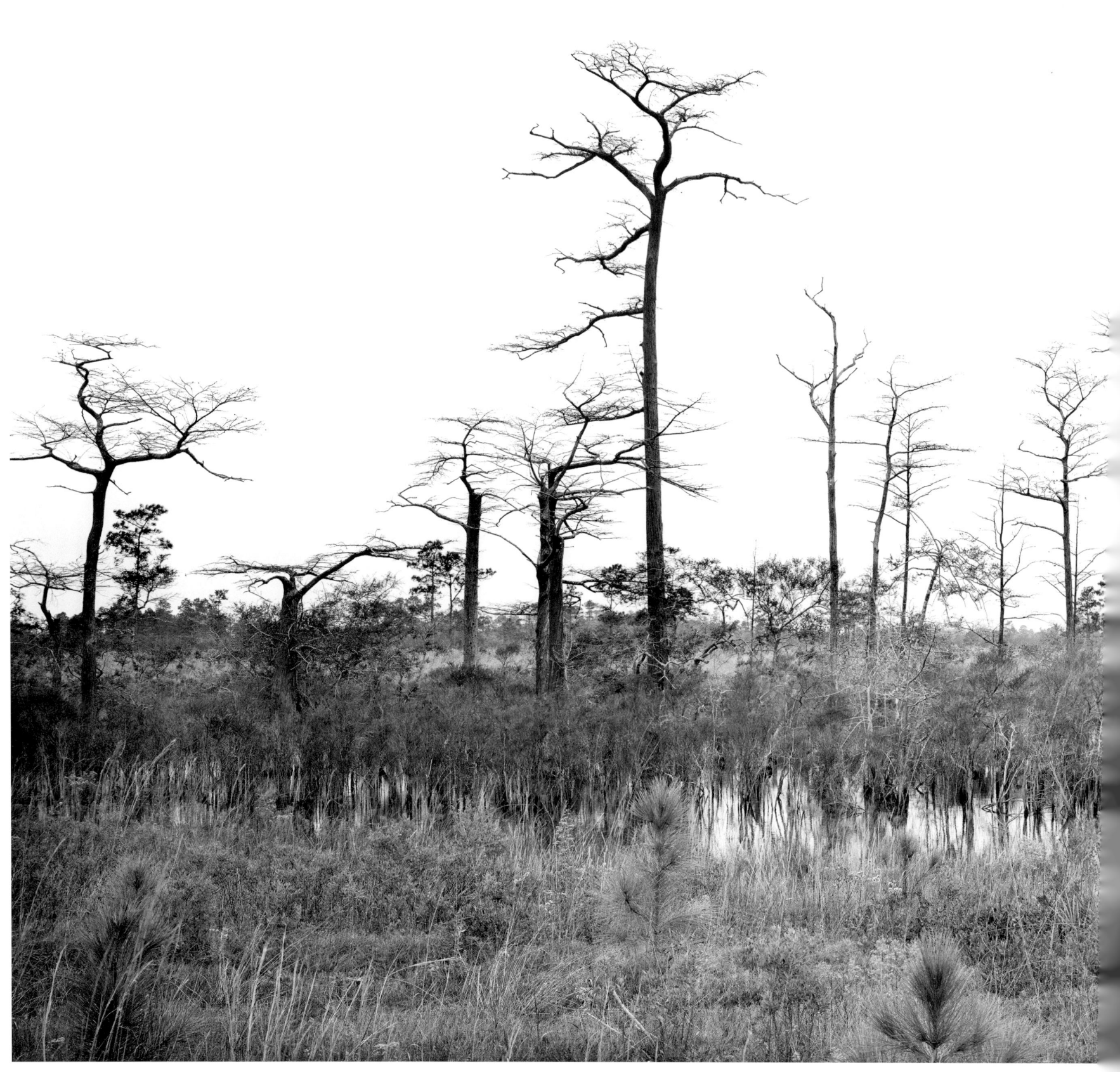

CYPRESS SWAMP IN WINTER [12]
POINT WASHINGTON STATE FOREST, FLORIDA 1993

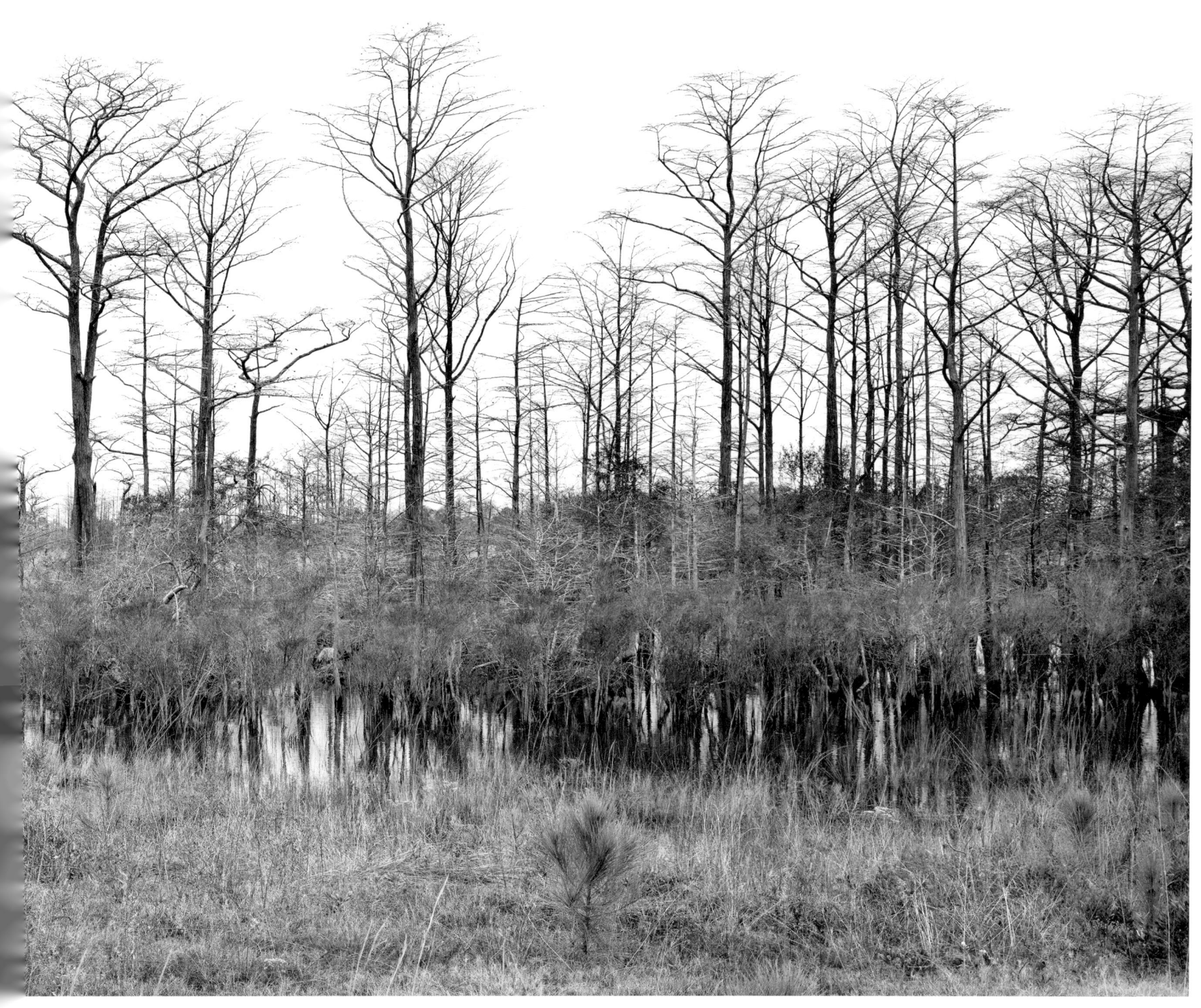

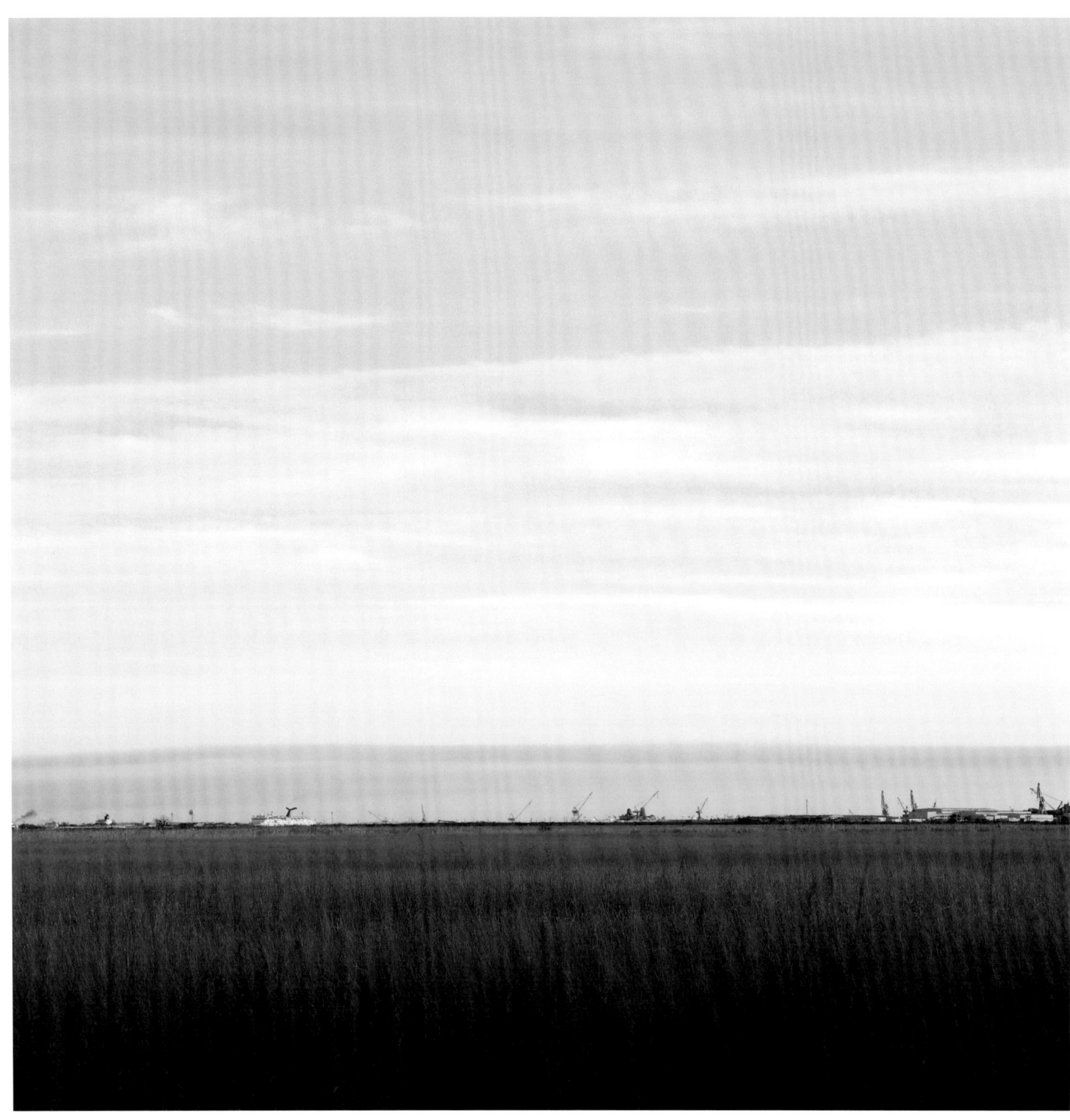

LANDSCAPE ABSTRACTION NO. 2 [13]
MOSS POINT, MISSISSIPPI 2006

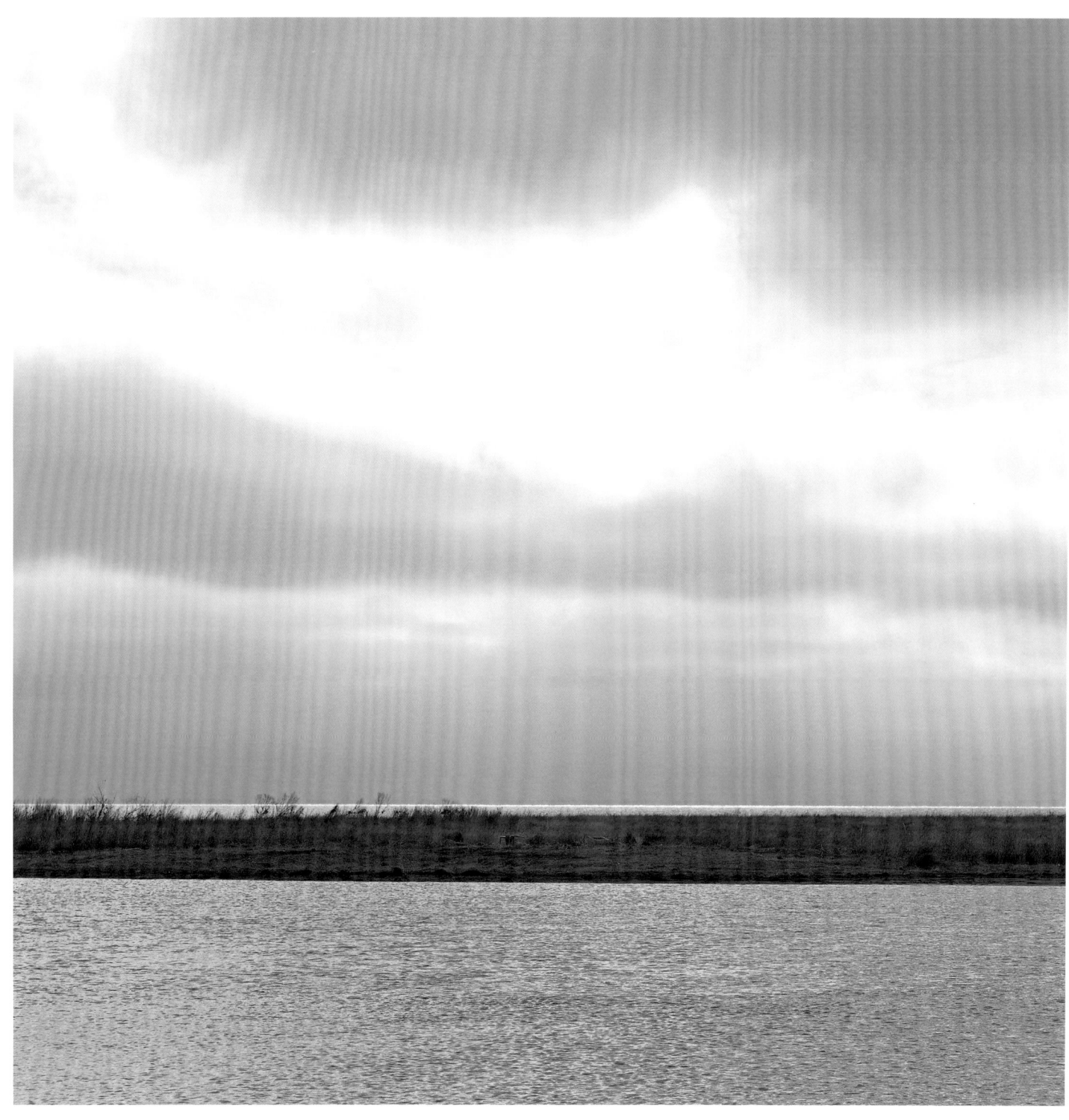

LANDSCAPE ABSTRACTION NO. 1 [14]
LAKE PONTCHARTRAIN AT IRISH BAYOU, LOUISIANA 2006

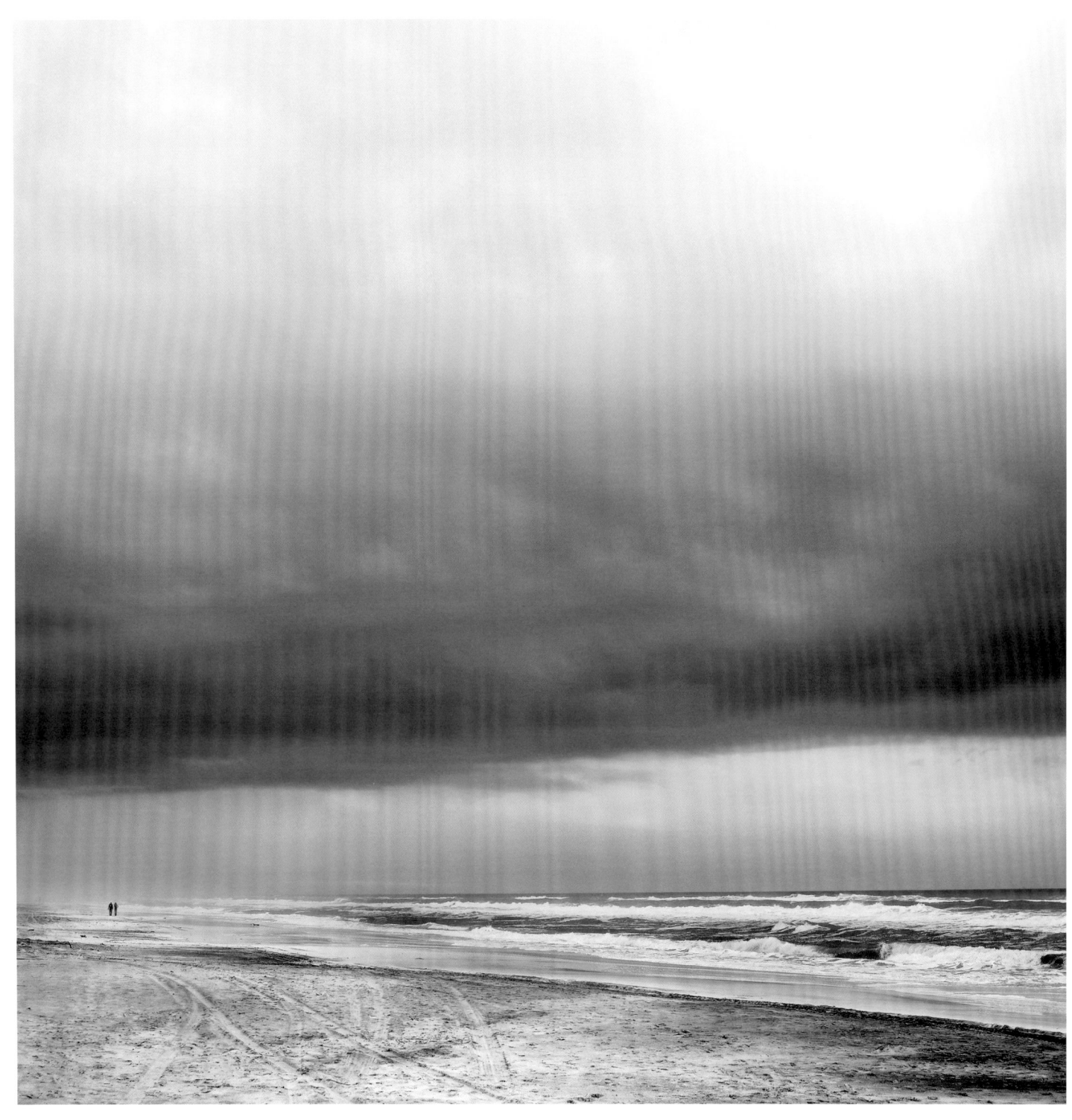

PERSPECTIVE STUDY: THE SCALE OF HOMINIDS TO NATURE [15]
SEASIDE, FLORIDA 2006

SYMMETRY STUDY: SEA AND CLOUDS [16]
SEASIDE, FLORIDA 2006

REFRACTIVE SUNSET [17]
SEASIDE, FLORIDA 2006

TRANSIENCE [18]
SEASIDE, FLORIDA 2006

DARK SEASCAPE [19]
GRAYTON BEACH STATE PARK, FLORIDA 2003

ECHO [20]
GRAYTON BEACH STATE PARK, FLORIDA 2003

DESCENSION [21]
GRAYTON BEACH STATE PARK, FLORIDA 2003

ASCENSION [22]
GRAYTON BEACH STATE PARK, FLORIDA 2003

EPHEMERA [23]
GRAYTON BEACH, FLORIDA 2004

WIND CONTOURS [24]
GRAYTON BEACH STATE PARK, FLORIDA 2006

DIVERSIONS [25]
GRAYTON BEACH STATE PARK, FLORIDA 2006

TEMPEST NO. 2 [26]
SEASIDE, FLORIDA 2006

TEMPEST NO. 1 [27]
GRAYTON BEACH, FLORIDA 2005

CLOUD STUDY [28]
GRAYTON BEACH STATE PARK, FLORIDA 2002

THE THREE STATES OF MATTER: SOLID, LIQUID, GAS [29]
LONG BEACH, MISSISSIPPI 2006

PIECE OF STYROFOAM ENCRUSTED WITH MARINE LIFE [30]
FOUND IN GRAYTON BEACH STATE PARK, FLORIDA 2006

GATEFOLD INTERIOR: PREVALENT LANDSCAPE [31]
GRAYTON BEACH STATE PARK, FLORIDA 2005

ATROPHIED SEASHELL [32]
FOUND IN GRAYTON BEACH STATE PARK, FLORIDA 2006

STOIC WITNESS [33]
BATTURE OF THE MISSISSIPPI RIVER, ALGIERS POINT, LOUISIANA 2005

TREE STUDY NO. 3 [34]
NEAR WEST POINTE A LA HACHE, LOUISIANA 2006

TREE STUDY NO. 2 [35]
WESTERN LAKE, GRAYTON BEACH STATE PARK, FLORIDA 2005

TREE STUDY NO. 1 [36]
WESTERN LAKE, GRAYTON BEACH STATE PARK, FLORIDA 2005

SPARE FOREST [3/]
NEAR REGGIO, LOUISIANA 2006

ENSEMBLE OF DYING TREES [38]
LAKE PONTCHARTRAIN, MANCHAC, LOUISIANA 2006

SOMETHING EVIL LURKS IN THE GARDEN [39]
EDEN STATE PARK, POINT WASHINGTON, FLORIDA 1992

ANGST [40]
COLQUITT, GEORGIA 1992

AFTERMATH DETAIL [41]
ALONG HIGHWAY 98, WALTON COUNTY, FLORIDA 1992

EVIDENCE OF MORTALITY [42]
REST AREA, HIGHWAY 90, DEFUNIAK SPRINGS, FLORIDA 1992

REQUIEM [43]
NEAR PASCAGOULA, MISSISSIPPI 2006

BAR OF SOAP AFTER A NEW ORLEANS RAIN [44]
FOUND IN FAUBOURG MARIGNY, NEW ORLEANS, LOUISIANA 2002

OYSTER SHELL [45]
FOUND IN GRAYTON BEACH STATE PARK, FLORIDA 2006

DEER MOSS [46]
FOUND IN DEER LAKE STATE PARK, FLORIDA 2006

GATEFOLD INTERIOR: A CADENCE OF PINE TREES [47]
ALLIGATOR LAKE, WALTON COUNTY, FLORIDA 2006

SAND PINECONE WITH LICHENS [48]
FOUND IN SEASIDE, FLORIDA 2006

NATURAL STATE [49]
NEW ORLEANS EAST, LOUISIANA 2006

REFLECTION [50]
MISSISSIPPI RIVER, ALGIERS POINT, LOUISIANA 2004

EVANESCENT HORIZON [51]
WESTERN LAKE, GRAYTON BEACH STATE PARK, FLORIDA 2005

SOLITUDE [52]
WESTERN LAKE, GRAYTON BEACH STATE PARK, FLORIDA 2005

FALLEN WILLOWS [53]
BATTURE OF THE MISSISSIPPI RIVER, ALGIERS POINT, LOUISIANA 2005

INTERLUDE [54]
COLQUITT, GEORGIA 1992

LANGUID MELODY [55]
CITY PARK, NEW ORLEANS, LOUISIANA 2000

MELANCHOLIA LURKING [56]
POINT WASHINGTON, FLORIDA 1992

A VIEW TOWARD CIVILIZATION [57]
POINT WASHINGTON, FLORIDA 1991

MEDIEVAL DREAMS [58]
EDEN STATE PARK, POINT WASHINGTON, FLORIDA 1992

THE FUTURE OF THE SWAMP [59]
NEAR CHIPLEY, FLORIDA 1992

BIRD'S FEATHER [60]
FOUND IN GRAYTON BEACH STATE PARK, FLORIDA 2006

BIRD'S NEST INCORPORATING HUMAN REFUSE [61]
FOUND NEAR MORGAN CITY, LOUISIANA 2003

UNBOTTLED MESSAGES: NEWSPAPERS IN SWAMP WATER [62]
NEW ORLEANS EAST, LOUISIANA 2006

TRYST SPOT [63]
GRAYTON BEACH STATE PARK, FLORIDA 2006

CIGARETTE LIGHTER WRAPPED IN SEAWEED [64]
FOUND IN GRAYTON BEACH STATE PARK, FLORIDA 2006

ORGANIC DEBRIS FROM HURRICANE OPAL [65]
FOUND IN GRAYTON BEACH STATE PARK, FLORIDA 2003

DIPTYCH: A STUDY IN SYMMETRY [66 & 67]
NEAR WEST POINTE A LA HACHE, LOUISIANA 2006

ENNUI [68]
ALONG HIGHWAY 98, WALTON COUNTY, FLORIDA 1992

DIPTYCH: A CADENCE OF TREES [69 & 70]
NEAR WEST POINTE A LA HACHE, LOUISIANA 2006

FROZEN DANCE [71]
DEER LAKE STATE PARK, FLORIDA 2006

SMALL INTERSECTION [72]
SEAGROVE BEACH, FLORIDA 1992

INTRICACY [73]
ALONG HIGHWAY 98, WALTON COUNTY, FLORIDA 1992

SIMPLICITY [74]
ALONG HIGHWAY 98, WALTON COUNTY, FLORIDA 1992

VEILED FOREST [75]
EDEN STATE PARK, POINT WASHINGTON, FLORIDA 1992

QUIET MOMENT BEFORE A REVELATION [76]
EDEN STATE PARK, POINT WASHINGTON, FLORIDA 1992

DISTORTED BY LIGHT [77]
EDEN STATE PARK, POINT WASHINGTON, FLORIDA 1992

FERTILE GROUND [78]
NEAR BURAS, LOUISIANA 2006

CACOPHONY [79]
NEW ORLEANS EAST, LOUISIANA 2006

LIVE OAK IN DEAD LANDSCAPE [80]
BAYOU SAUVAGE, LOUISIANA 2006

ELEGIAC MOMENT [81]
YSCLOSKEY, LOUISIANA 2006

CAPITULATION [82]
YSCLOSKEY, LOUISIANA 2006

AFTERWORD
Delicacy, Damage, and Dynamism
By Randy Harelson

Looking at the photographs by Richard Sexton, one realizes quickly that he is not just taking pictures of pretty places. The places to which he is drawn are dynamic, rapidly changing, and often damaged. He is drawn to the real world of nature as we know it in the twenty-first century. He finds his subjects in the same way most contemporary Americans see nature: from the car, or on foot a short walk from home or from the parking lot. His territory is the Deep South between New Orleans, Louisiana, and Panama City, Florida.

The landscape of the Gulf Coast of the southeastern United States is little-known, unexplored, and often unappreciated even by the people who live there. At first look it is not a grand, majestic landscape, perhaps because it is very flat, and therefore unobstructed vistas only occur down rivers, across mowed fields, or from the beach. Woods tend to be dense, full of tangled vines and unfriendly wet places. The largest old-growth trees grow mostly in inaccessible places, hence their escape from the lumberman's ax. But it is a beautiful landscape full of mystery, delicacy, doggedness, and, especially, romance.

The places Richard has photographed are mostly close to sea level, and in fact mostly close to the sea. From New Orleans east through Mississippi and Alabama to the panhandle of Florida, the landscape is basically the same. One distinct difference from west to east is the topsoil.

The southeastern coastal plain is built upon limestone and dolomite, marine sediment deposited when the whole area was undersea. Clay, silt, sand, and gravel have been carried down the Southern rivers from the Appalachian Mountains over millions of years and layered atop the ancient marine sediment.

The spectacular, pure white sand beaches that Richard photographs are topped with a deep layer of almost pure quartz crystal sand. This sand was once part of Appalachian mountain granite, broken apart and redistributed by the steady and tireless power of nature. The clarity of the sand beneath the surf accounts for the stunning turquoise and emerald waters of the Gulf along Florida's panhandle.

But to the west, New Orleans is built on the deep topsoil of the Mississippi River Delta. Rich, moist, and black, this soil has been built over millions of years by the river's annual floods that bring organic matter and minerals from as far north as Canada. If you look at satellite photos of the Gulf of Mexico, you can actually see the dark deposit of the Mississippi staining the waters as far east as Alabama.

The Gulf Coast has relatively mild winters, but that is the only thing mild about its weather. Sudden freezes, explosive wind bursts, flooding rains, thunderstorms often accompanied by spectacular lightning, tornados, hurricanes, long periods of drought, and months of summer temperatures exceeding ninety degrees are expected. An old Southern saw is, if you don't like the weather, stick around a little while.

Frequent electrical storms mean frequent fires, and an ecosystem that depends on fire has evolved over millions of years in this region. Many of the plants of the Gulf Coast grow primarily underground and lose relatively little of themselves to fire. The saw palmetto *(Serenoa repens)* pictured in *Phoenix Palmetto* [plate 06] is a palm tree that grows with its trunk covered safely underground. But the drama is still staged above ground, and Richard's photographs of the woods after fire attest to the phoenix-like quality of new life from the charred remains of the old.

Similarly, hurricanes and tornados bring winds that break and shape almost all the plants of the Gulf Coast. The constant wind off the Gulf carries a certain amount of salt from the water, and wind prunes the oaks and other woody plants that grow as scrub in the dunes above the shoreline. The shapes of these plants are almost always lopsided, leaning away from the water. Often these trees close to the beach get covered by sand and survive with just the tips of their branches reaching above the surface. The tree in *Echo* [plate 20] is no longer visible in Grayton Beach State Park where Richard photographed it just a few years ago.

Louisiana is one of the wettest places in the United States, renowned for its bayous and swamps. But just a few hundred miles to the east in the Florida panhandle, the landscape is what scientists call a "desert with rain." It is remarkable to note that so many of the Gulf Coast plants and trees grow under both conditions. Oaks, pines, bald cypress (in depressions), Southern magnolia, and different species of palmettos and grasses inhabit Richard's photographs, reminding us of the continuity of the southeastern coastal plain.

In many of these photographs, vines wrap the landscape in an intricate and beautiful tangle. Wild grape, woodbine, cross vine, trumpet vine, greenbriers, and other smilax make up this complex scribble in three dimensions.

In some pictures, such as *Evidence of Mortality* [plate 42], one is reminded that not all the Southern landscape is native. Kudzu, an exotic (now infamous) invasive vine, was introduced to America from its native Japan in 1876 and promoted, propagated, and disseminated from a nursery in Chipley, Florida. It has now covered more than seven million acres of the Deep South, smothering entire forests. Finding kudzu in a roadside park, Richard takes out his camera. He sees the quiet stories of life and death contained in neglected and ruderal sites.

But perhaps most of all, the grand live oak *(Quercus virginiana)* of the Deep South dominates the landscape and these photographs. These great trees, living hundreds of years, their serpentine branches sometimes leaning down to touch the ground, are whole worlds unto themselves. In Richard's photos you often see the limbs covered with small, dense ferns and the branches draped with a filigree of silvery tinsel. The fern is resurrection fern *(Pleopeltis polypodioides)*, so named because in periods without rain its fronds curl up dry and brown and look entirely dead; then, after a rain, almost immediately the fronds unfurl green, fresh, and fully alive. The silvery tinsel is Spanish moss *(Tillandsia usneoides)*, not a true moss but an epiphyte, or air plant. Live oaks are teeming with life in the canopy and on the ground beneath, where their multitude of acorns provide food for squirrels, turkeys, hogs, mice, opossums, deer, and armadillos. Squirrels chase through live oak canopy like children at recess. Owls, woodpeckers, warblers, bats, snakes, toads, lizards, skinks, cicadas, and hairstreak butterflies all inhabit the world of the live oak canopy.

In 2005, Hurricane Katrina did massive damage to the live oaks of the coast. Stripped of their leaves and smaller branches, many live oaks have leafed out again and appear to have survived. But it will be years before the full impact of the storm can be fully assessed. Richard's photographs provide a record of the landscape at the dramatic turn of a new century.

Remarkably, many of Richard's photographs deal with the power of air. Winds leave landscapes broken and scattered. Massive clouds gather ominously over the Gulf. Thick fog turns tree-lined lake shores into shadow pictures. The characteristically high humidity of the Gulf Coast makes the air unusually noticeable, and makes one more aware of temperatures high or low. Southerners say the air is "close," and Richard seems to capture that with his camera.

Accordingly, in Richard's pictures, skies are not backgrounds. The clouds and air move directly into the foreground and participate forcefully with earth and sea. They can capture in a moment the enormous connection of the elemental forces of solid, liquid, and gas. In *Perspective Study: The Scale of Hominids to Nature* [plate 15], one loses track of where the earth ends and the sea begins. We think we know that the beachcombers walk on earth. But look again. Are they walking on water, or maybe even clouds? In *Refractive Sunset* [plate 17], sunlight appears as another element, and reminds us that the photographer almost magically creates his images with pure light. For a moment we are able to see how evanescent our lives are on this tiny planet floating through space.

We share our lives on Earth with many other creatures, most of whom we never see. The Gulf Coast and other coastal regions are relatively small; they make up less than 10 percent of our country's land area. But along with a higher concentration of human population, they support thousands of species of plants and animals, most unknown to the people who live among them. Many of these species are threatened or endangered due to the pressures of residential and industrial development, but also to the natural disasters apparently increasing because of global climate change and the warming temperatures of the oceans. Fish and other marine animals, waterfowl, migrating songbirds, hummingbirds, reptiles, amphibians, and mammals are all affected.

Richard's pictures of this little-noticed landscape may remind us of its strange beauty, its slow and soft-spoken story, and, ultimately, its value, not only to us, but to its multitude of other inhabitants.

The first poetry is always written against the wind by sailors and farmers who sing with the wind in their teeth. The second poetry is written by scholars and wine drinkers who have learned to know a good thing. The third poetry is sometimes never written; but when it is, it's by those who have brought nature and art together into one thing.
—Walter Inglis Anderson (1903–65)

ACKNOWLEDGMENTS

More so than with any of my other book projects, *Terra Incognita* reached fruition solely because of the help, encouragement, support, and involvement of numerous individuals and organizations who believed in it. I'd like to begin by thanking my publisher. This is the eighth title I've produced in collaboration with Chronicle Books. I signed my first publishing agreement with them twenty-two years ago. It is in no way an overstatement that were it not for Chronicle Books, my career in photography would have flickered out long ago. The ability to execute extended photo essays of my own choosing was vital to my career and was not afforded elsewhere. I'm grateful to everyone at Chronicle Books, not just for this title, but for all the others that led up to it. I'd particularly like to thank Jack Jensen, who was this project's staunchest advocate and, beyond that, is a good friend. My editor Alan Rapp was a joy to work with, cared deeply about this title, and guided it thoughtfully to completion. Vanessa Dina created a beautiful book design. I only hope my photographs have lived up to it.

Rick Gruber, Randy Harelson, and John Lawrence graciously shared their insights, knowledge, and observations of my work and my subject. Their respective written contributions greatly enrich this book. I'm honored that individuals of their stature were willing to make such a substantial contribution to this book. I'd like to thank the Ogden Museum of Southern Art for participating directly in this project by organizing an exhibition of my photographs concurrently with the book's release. The Ogden granted me my first major museum exhibition in 2005, and I'm deeply grateful for the validation and recognition it has brought to me. I'd specifically like to thank Rick Gruber and David Houston of the Ogden Museum of Southern Art for making an exhibition of the work from *Terra Incognita* possible.

Jonathan Traviesa, my assistant and studio manager, has been intimately involved with the production of *Terra Incognita*. He has helped in critical ways with every phase of the project over the last several years. I literally could not have done it without him.

Like everyone else who has ever picked up a camera and called himself a photographer, I'm deeply indebted to those photographers who came before me and whose work inspired me. I stole a lot of their ideas. That said, there's a difference between visiting and trespassing, and one of the key distinctions is to recognize and respect those whose turf you are treading on. Toward that end, I'd like to acknowledge my most significant artistic influences. In alphabetical order, they are: Eugene Atget, Bernd and Hilla Becher, Karl Blossfeldt, Frederick Evans, Walker Evans, Edward Hopper, David Ireland, Clarence John Laughlin, Irving Penn, Charles Sheeler, Josef Sudek, and Edward Weston.

This project began in 1991. My career in photography began almost twenty years before that. Many people and institutions have helped me along the way, and space doesn't allow me to articulate when and where their help and support ultimately saw fruition within these pages, but I at least have room for their names, which are given in alphabetical order on the facing page. Many thanks to all of you.

Laura Arrowood
Bayou Tree Service
Dorian Bennett
Mike Blumensaadt
Susan Bridges
Henry Brimmer
John Bullard
Michael Carabetta
Eugene Cizek
Sandra Russell Clark
Dotty and Jimmy Coleman
Barbara Cushman
Robert Davis
Randolph Delehanty
Lake Douglas
Sid Fisher
A Gallery for Fine Photography

William Greiner
Jeannette Hardy
Harrah's Design and Construction
Edward Hebert
The Historic New Orleans Collection
Thomas Ingalls
Sheila Kelley
Mya Kramer
Bill LeBlond
Herman Leonard
Louisiana Cultural Vistas Magazine
Alex MacLean
New Orleans Academy of Fine Arts
New Orleans Museum of Art
Ray Oldenburg

Joshua Mann Pailet
Paul Raedeke
Samantha Richter
Charles Routhier
Victoria Ryan
Michael Sartisky
Marvin Sexton
Elizabeth Shannon
Southern Accents Magazine
Sam Still
Carter Tomassi
William Turnbull
Griff Williams
Sally Woodbridge
Suzanne Zinsel

The author and publisher gratefully acknowledge the efforts of the Nature Conservancy to protect and restore the natural environment of the Gulf Coast. A portion of the author's royalties and the publisher's profits from the sale of this book are being donated to the Nature Conservancy.

This book is accompanied by the exhibition *Terra Incognita: Photographs of America's Third Coast*
The Ogden Museum of Southern Art, New Orleans
October 6, 2007–January 2, 2008
www.ogdenmuseum.org

BIOGRAPHIES

Richard Sexton was born in Atlanta in 1954, and raised in Colquitt, a small farming community in southwest Georgia. Predominantly self-taught as a photographer, he began taking pictures while he was an undergraduate student at Emory University. He was an early member of Nexus, a cooperative photography gallery founded in Atlanta in the 1970s for local photographers to have their own space to exhibit their work. After graduating from Emory in 1975, he moved West and briefly attended the San Francisco Art Institute in 1977 and 1978. In late 1979, he began a career as a commercial photographer in San Francisco, specializing in interiors and architecture. In 1987, he published his first book with Chronicle Books, beginning a relationship that has continued to the present; *Terra Incognita* is the latest of eight titles with Chronicle, which have also included the best-selling *New Orleans: Elegance and Decadence* and *Vestiges of Grandeur: The Plantations of Louisiana's River Road*. Sexton's work has been published in numerous magazines in the United States and Europe, including *Abitare, Archetype, Architectural Record, Garden Design, Gulliver, Harper's, Landscape Architecture, Louisiana Cultural Vistas, Photo Metro, Preservation, Smithsonian, Southern Accents,* and *View Camera*.

In 1997, Sexton curated the exhibit "Sidney Bechet: A World of Jazz 1897–1997," which commemorated the centennial of the highly influential jazzman's birth, for the Bechet Centennial Committee. In 2005, he received his first major museum exhibit at the Ogden Museum of Southern Art in New Orleans. This exhibit featured work from a handmade fine art book, *The Highway of Temptation & Redemption: A Gothic Travelogue in Two Dimensions,* self-published in 2004. Sexton's photographs are included in the collections of the Historic New Orleans Collection, the New Orleans Museum of Art, the Ogden Museum of Southern Art, and numerous private collections. His multidisciplinary studio is located in Faubourg Marigny in New Orleans. Since the mid-1990s, he has taught photography at the New Orleans Academy of Fine Arts. Additional information regarding Richard Sexton's work and gallery affiliations is available on his Web site: www.richardsextonstudio.com.

J. Richard Gruber, Ph.D., has been Director of the Ogden Museum of Southern Art, at the University of New Orleans, since 1999. Prior to joining the Ogden, he served as Deputy Director of the Morris Museum of Art in Augusta, Georgia; as Director of the Wichita Art Museum in Wichita, Kansas; as Curator, then Director, of the Memphis Brooks Museum of Art in Memphis, Tennessee; and as Director of the Peter Joseph Gallery in New York. After graduating from Xavier University in Cincinnati, he earned an M.A. in art history from the University of Colorado at Boulder, then a M.Ph. and a Ph.D. in art history from the University of Kansas at Lawrence. He has published numerous books and catalogues, including *Dunlap, Missing New Orleans, William Christenberry: Art & Family, Robert Stackhouse, Wolf Kahn: Painting the South, Thomas Hart Benton and the American South, American Icons: From Madison to Manhattan, Robert Rauschenberg: Through the Lens, Nellie Mae Rowe,* and *The Dot Man: George Andrews of Madison, Georgia*.

John H. Lawrence is Director of Museum Programs and Head of Curatorial Collections at the Historic New Orleans Collection. A New Orleans native, Lawrence has written and lectured widely about contemporary and historic photography, and the administration and preservation of pictorial collections. He has curated dozens of exhibitions and contributed to numerous books and publications, including *Clarence John Laughlin: Visionary Photographer, Haunter of Ruins: The Photography of Clarence John Laughlin, Marie Adrien Persac: Louisiana Artist, From Louis XIV to Louis Armstrong, Common Routes: St. Domingue-Louisiana, Printmaking in New Orleans,* and *Creole Houses: Traditional Homes of Old Louisiana*. Lawrence also chairs the Williams Prize Committee of the Louisiana Historical Association. He has been a contributing editor of the *New Orleans Art Review* for more than two decades, and has provided frequent book reviews to the journal *Louisiana History*. He holds degrees in literature and art history from Vassar College, and a certificate in museum management from the Getty Leadership Institute.

Randy Harelson is the owner of the Gourd Garden Courtyard Shop in Rosemary Beach, Florida. The Gourd Garden won the Florida Nursery, Growers, and Landscape Association's S.J. Blakely Award in 2003, and it has been chosen by *Garden Design* magazine as one of "25 great garden shops in America." Randy has taught and written about art and horticulture for more than thirty years, in Louisiana, Massachusetts, Florida, and Rhode Island, and worked as designer and assistant horticulturist at Blithewold Mansion, Gardens & Arboretum in Bristol, Rhode Island. He has championed preserving the native landscape of the Florida Gulf Coast, in particular the new urban towns of Seaside, Rosemary Beach, and Draper Lake. His garden designs have been published in *Southern Living, Southern Accents, Veranda, Garden Design,* and *Horticulture* magazines, and he is the illustrator of *American Border Gardens* by Melanie Fleischmann. He is currently restoring the LeJeune House, an early 19th-century plantation home and garden in New Roads, Louisiana.

FRAGILE RELATIONS [83]
NEW ORLEANS FROM PARIS ROAD, CHALMETTE, LOUISIANA 2006